OUT OF THE SHADOWS
SHADOWS
A Life of Gerda Taro

François Maspero

Translated from the French by
Geoffrey Strachan

SOUVENIR PRESS

To Anaïk Frantz

from whom I learned to share her passion for photography in the course of our journeys together on the Roissy-Express

First published in English, 2008, by Souvenir Press Ltd
43 Great Russell Street, London WC1B 3PD

Translated from the French
L'ombre d'une photographe, Gerda Taro
Published by Éditions du Seuil 2006
© Éditions du Seuil, March 2006

© English translation 2008 Souvenir Press and
Geoffrey Strachan

This book has been published with the support of the French Ministry of Culture – **Centre National du Livre** – and the support of the Ministry for Foreign and European Affairs (DGCID) and the Embassy of France in London (Cultural Department)

ISBN 9780285638259

Typeset by M Rules
Printed in Great Britain

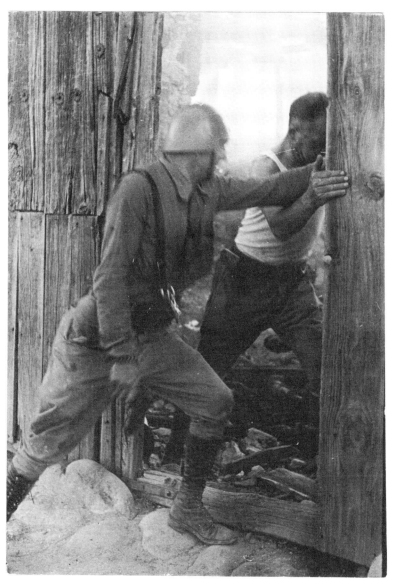

1. Brunete, July 1937.
Photo: Gerda Taro.

Illustrations

ONE

La Pequeña Rubia

I have dreamed about this interview for years.

She lives in a quiet alleyway in the fourteenth arrondissement of Paris. I have finally been granted an appointment. 'When she's not travelling,' I am told, 'which is rare these days, she lives very privately, among her photographs and her cats. She says she no longer has any time to lose.' It is spring, a lilac tree, a mass of white blossom, leans out over paving stones with stubborn grass sprouting between them. Here and there old studios have survived the town planners' great upheavals. At the end of the alley there is a little door. I ring the bell. It is opened by a woman of indeterminate age who confirms that I am expected. I climb up a narrow staircase. This leads into a large space dappled with sunlight filtered through blinds. There is hardly time to make out the shapes and colours of a Max Ernst and a Leonor Fini. I follow the woman into a long corridor. The light in the little room at the end

of it is more muted. I sit down in an armchair covered in greyish-beige velvet, a wing armchair, k&k, *kaiserlich und königlich*, the Biedermeyer style beloved of the subjects of His Majesty the Emperor Franz Josef. Two further identical chairs are arranged round a little table on which coffee cups are laid. They look like old family furniture and this is possible, after all: in the year of her birth the Emperor and King was still at the height of his reign. A spindly bird on a console table looks to me very much like a sculpture by Giacometti. In the depths of the nearest armchair, a cat with a tawny coat and dark brown ears and tail is stretched out, fast asleep, and barely opens its eyes at my arrival, just the time it takes to show a flash of green and gold. I study the walls: they are completely covered with glass-framed photographs and all of them, without exception, are of cats. I recognize a few of them, I have seen them in some of her innumerable illustrated albums, and even on postcards. In the most varied poses, taken from the most diverse angles. Always with that strange piercing look cats have, which seems to pass right through you, travelling on to where? Prints in black and white alternate with ones in colour. The woman I am waiting to see is the most celebrated cat photographer in the world today. But how can everything else be forgotten?

She appears in the doorway from the corridor, walking with brisk little steps. I had indeed been told that she was astonishingly sprightly for her ninety years and more. A very upright carriage. As her eyes focus on me, I see the same gleam as I had glimpsed in the eyes of the cat, which has suddenly stood up in its chair. She sits down there and

takes it on her lap. She is small. Tiny. Fragile and yet solid. A delicately lined face. Her short white hair forms tight curls on her brow. She smiles at me. She asks me if I would like some coffee. Her slight accent, something about the way she rolls her r's, is evocative of central Europe.

The ageless woman brings her a cushion and serves the coffee. Meanwhile she talks to me about cats. 'They're my whole life. I owe them everything. They keep me company and they've provided for me in my old age.' There is a hint of irony in her laughter.

She strokes the head of the one purring on her lap just between the ears and it gazes up at her. 'I love the way they look at you. Don't you?' I assure her that I do too. I ask her to tell me how this long-term passion came about. In saying this I am thinking more of photography than of cats. She closes her eyes for a moment: 'When I was still quite little . . .' She picks her way through memories, Stuttgart, Leipzig, the Pension Florissant in Geneva and then that dreary room on her arrival in Paris . . . Her first photograph? 'He came in at the window one day, he was almost as thin as me, and I can still feel his coat rubbing against my bare legs as if it was yesterday. I gave him some milk and he stayed. It cheered me up to find him there on certain evenings when I was alone. I called him Bob.' So her first photograph was that one of a cat? 'Yes, of course.' But what did she do about him when she travelled? At that time she often used to go away for long periods. 'One day he must have had enough. I found the window open and the room empty.'

I am loath to be the first to utter the word, 'Spain', but I have to resign myself to this. 'Ah! You want me to talk about those days . . . But it's all so long ago.' She falls silent for a moment. 'They all used to call me *la pequeña rubia*, the little blonde. Hemingway: what an impossible braggart. Dos Passos: I admired him very much but he always moaned about everything. Alberti and his wife: they were so concerned about me and took me under their wing. Gustav Regler, who thought he was a great politician. And Koltsov, who sang the praises of the Soviet paradise to us, which did him no good, poor man. They're all dead, in any case. By day we would go to the front. At night we argued and had a party. We hardly ever slept. People were getting killed all around us, they were dying of hunger and poverty. But we believed in victory, we drank to victory. We could see nothing else. Because, for us, it simply wasn't possible: *they* could not pass, *they* would not pass. We were innocents.'

I suggested that she might have known some moments of happiness down there. Her eye travels along the photographs on the wall. 'They courted me . . . The sweetest of them all was a boy called Ted Allan. So good looking! At twenty-one he was the political commissar in the medical unit run by an American communist whose name I don't recall. But he was forever moralizing. And what's more he fancied himself as my protector. A real macho man, as you say these days. But in the end it may be thanks to him that I'm alive. Because when I was wounded at Brunete – oh yes, I was wounded, and badly, too: one of those hopeless Russian tanks that got out of

control as soon as they arrived and the militiamen who didn't know how to drive them. Let's see, what year was it . . . 1937? That's it, July 1937. I remember the date, it was a few days before my birthday, I was going to be twenty-seven . . . Ted managed to take me back to Madrid . . . There was a gaping wound in my stomach, you know. I should have stayed put. It was hell. Later he wrote to me from Canada. He wanted me to join him there. It wasn't a bad idea, except that he wanted us to get married . . . If I'd said yes, I shouldn't have had to go through that terrible year in France, 1940. Or the internment camp at Pithiviers. Or the interminable wait in Marseille. Or that stinking cargo boat, the *Capitaine-Lemerle.* No danger of my forgetting that name. With those pretentious fellows on board: André Breton, Victor Serge. And starving in Mexico . . . More hell. Lost in the crowd. I thought I was doomed to end up as a street photographer. Impossible to get a visa for America. I was a dangerous communist. I don't know why they stuck that label on me for so long. But I was lucky all the same; my photos of peons, Indian peasants, in Guerrero, in Chihuahua, in Chiapas . . . I was asked for some only yesterday, very old ones, to illustrate a book on sub-commander Marcos. It's a shame I'm too exhausted to go and photograph him on the spot. I like that old Zapatista, you know. Then there was the trip up the Orinoco with Gheerbrant. I linked up with the Black Star Agency again, but I didn't want to join Magnum. They'd started up without me so I wasn't going to approach them . . . And then, in the end, during these past years,

I've come back to my first love: cats. I'd been neglecting them for too long. But they never let me down.'

So am I the one who is going to have to mention the name of Robert Capa? Time is rushing by and nothing suggests that she is going to make even a passing reference to him: The silent woman has returned several times to hover round us and I sense that what will come up at any minute now is her great age and weariness. I have to risk it.

That look again: so alive, unscathed by the wear and tear of the years. A look that pierces right through me too, travels beyond me and is lost far, far away.

'I knew you'd come to that . . . You all come to it in the end. It's an obsession.' A long silence. Then: 'Capa . . . André, that poor boy: that stupid death in Indochina . . . I called him Bob right away, he was so like my first Parisian tomcat. He came into my life one day, just like that one. And then, like that one, he ran off. I thought I was going to meet up with him in Paris again, but he'd already gone to China. I never saw him again. But it's so long ago, all that. Him and all the rest . . .'

Then she says: 'Capa? Oh, you know, I don't hold it against him.'

And then: 'It lasted less than three years. But no one can imagine how happy we were together.'

She stops there. The silent woman clears the cups away. It is time to go. In the little street the sun has vanished and the spring with it.

*

6

An interview only dreamed of. An imaginary interview. Yes it is true, Gerda Taro was indeed wounded on the evening of July 25 1937, on the road from Brunete to Madrid, as the German Stukas and Heinkels of the Condor Legion unremittingly machine-gunned and bombed the republican troops in full retreat. One of the pilots, Werner Beumelburg, complacently relates that what he observed beneath his aircraft that day was: 'a furnace', a vision of 'the Last Judgment', 'a job really well done.' But this is where Gerda's story comes to an end. She died in the hospital installed at El Escorial in the small hours. Died and what is perhaps worse, slowly vanished with the passing years, swallowed up in that eclipse of memory which, three thousand years ago, Homer described as being more terrible than death itself. She survived for a time in people's recollections, an increasingly shadowy figure, until there is now almost nothing left of her: apart from a few pictures and an oft repeated tale, a vague legend, which tells that for a time she was the companion of the unparalleled Robert Capa, the greatest war photographer of all time. The woman whose death left him inconsolable and whom – on his frequent evenings of depression and drunkenness – he claimed to have married.

A shadow lost in the shadows, Gerda Taro suffered the most cruel fate that a shadow can know: that of not even being her own shadow. That of being someone else's shadow. In the course of more than sixty years whenever one looked for her name, it was sure to be mentioned hundreds of times. But always associated in a few lines, a few pages, with the man whose life she shared for a time.

Nothing more. A passing role in the biography of a famous person, one of which only muddled and confused traces remained, often contradictory, false, sometimes absurd. To discover photographs signed with her name it was necessary to delve into a few yellowed copies of newspapers from 1937. Or possibly, with a bit of luck, decipher her signature on the back of a print beneath a deletion or an alteration giving a different attribution. She has only recently emerged from oblivion. In 1994, as a result of patient research, a German scholar, Irme Schaber, succeeded in piecing together and following through the lost thread of a life of almost twenty-seven years. Her book *Gerta Taro: Fotoreporterin im Spanischem Bürgerkrieg* ('Gerta Taro: a photojournalist in the Spanish Civil War') is now published in France. And detailed studies in recent years in various collections, including those preserved by Cornell Capa, brother of Robert, and the International Center of Photography in New York have finally made it possible to identify some 300 photographs, resulting in an exhibition and a complete catalogue.

*

She was, say those who knew her, 'incredibly light'. What could be read in her face, wrote Rafael Alberti, was 'a delight in danger, the smile of an immortal, dynamic, courageous youthfulness. I do not know if she was unaware of it but it was, at all events, resolute, irresistible.'

A delight in danger? I am not sure. A few days before

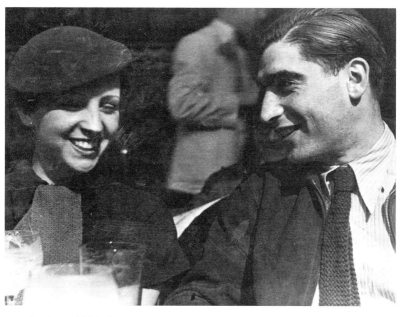

2. Paris, 1935. Gerta Pohorylle (the future Gerda Taro) and André
Friedmann (the future Robert Capa).
Photograph by Fred Stein.

her death she confided to one of her colleagues, Claud Cockburn of the *Daily Worker:* 'When you think of all the fine people we both know who have been killed even in this one offensive, you get an absurd feeling that somehow it's unfair still to be alive.'

The smile? Yes indeed. The pictures of her bear witness to it. The smile of the young schoolgirl in the nineteen twenties. One imagines the photographer hunched over his camera on its tripod, addressing the ritual instruction to her from under his black cloth: 'Smile, Mademoiselle' – and she would certainly not have to force herself, already confident of her charm. A smile glowing with happiness beside André Friedmann, who was not yet called Robert Capa, in 1935. A triumphant smile, even roaring with laughter, on her first press card, a hundred leagues away from the conventional grimace which is generally paraded on documents of this kind. A seductress's smile – both seductress and seduced? – in a photograph taken by Capa at the same period, one that warrants the old fashioned term, 'snapshot', so much does it reveal the intense and all too brief state of grace in which the exchange, almost the fusion, of two glances, each marvelling at their new love, is transmitted by the lens. Yet another smile, almost greedy, responding to a bouquet of lilies of the valley in the streets of Paris on May 1st 1937. And then there is the smile that one senses, though it is hidden by the Leica, as she closes one eye and points it at who knows what, when taking pictures at the front in Spain in 1937. And so on up to that very last smile, the same as the one that featured on her

first press card, which appeared again on the front page of *Ce Soir* for July 28 1937 beneath the big headline underlined in black: 'Our photo reporter MLLE TARO KILLED NEAR BRUNETE where she was present at the fighting.'

Unaware? Well it was certainly no coincidence that one of the last stories which appeared with her byline in *Regards* was published under the prophetic heading, too little understood at the time: 'DRESS REHEARSAL FOR TOTAL WAR.'

Irresistible? A slender figure, never still, crowned by a head of auburn curls with the glint of fire. People said she was a will-o-the-wisp.

※

Rafael Alberti who, with his wife, Maria Teresa, ran the Alianza de los Intellectuales Antifascistas in Madrid, recounts in his memoirs how he was woken at dawn on July 26 1937. They were telephoned from the 'El Goloso' hospital that had been installed at El Escorial. A severely wounded young woman had been brought in from the front near Brunete. She had just died. They had found no papers on her. If she could not be identified she would have to be entered as an unknown person. 'We immediately set off for the mountains, Maria Teresa and I, without having the slightest idea of who this could be. There in a corner we saw the bloody face, almost entirely covered with dressings, her body covered by a sheet – who could have imagined it, my God! – of Gerda Taro, Robert

Capa's companion, that strikingly beautiful young woman who believed herself invulnerable, as we all had. A nurse said to us: "She was already in a dreadful state on arrival but still alive. We had to operate without an anaesthetic, we had no supplies. She was unable to speak. She made the gesture of asking for a cigarette. She chewed on it furiously and died during the operation."'

A curious name for a hospital: 'El Goloso' means 'the man with a sweet tooth'.

Rafael and Maria Teresa Alberti transported Gerda Taro's body to Madrid in a coffin hastily put together from planks. 'During our journey the pine groves were on fire. The Franco aircraft were bombing everything that emerged from El Escorial, the last residence of Philip II. We finally reached Madrid unhurt and there in the Winter Garden of the Alianza de Intellectuales Antifascistas Españolas we kept watch over Gerda, the little heroine, as if she were a soldier, which was what she had truly and generously been, in the defence of our Republic under cowardly attack . . .' (Here follows a flight of lyricism, which the reader may be spared.) 'Everything I knew about photography I had learned from her. On my return from a trip to the Soviet Union, where they had given me a superb camera, I had bought an enlarger. Gerda Taro had shown me how to develop and print my first photographic studies, patiently teaching me all I needed to know to succeed in obtaining pictures of our struggle. As the militia were paying her their last respects and trade unionists, military leaders, painters and writers and people who lived in that district and had heard the news

were filing past her, this is what came back to me . . .'
(Here another lyrical flight.)

*

In that month of July 1937 Madrid, starving, battered by
bombardment from Franco's forces, the fighting at its
gates often hand to hand, had been holding out for a year.
Hope was reborn when their grip was seen to be loosen-
ing. The Alianza, the Alliance of anti-fascist intellectuals,
at the centre of the city was a caravanserai that gave
asylum to the intelligentsia of the whole world. The
second Congress of the International Association of
Writers for the Defence of Culture had just finished. It
was held first at Valencia, which had become the seat of
government, then in the capital. Those present included
André Malraux, Ernest Hemingway, John Dos Passos,
W.H.Auden, Claude Aveline, Gustav Regler, Anna
Seghers, Alexis Tolstoi, Mikhail Koltsov, José Bergamín,
Pablo Neruda, Tristan Tzara, Louis Aragon, Paul Nizan,
Ilya Ehrenburg . . . two hundred writers from twenty-six
countries, there to bring their support to the republican
cause. This meeting was a sequel to the Congress that had
been held in Paris in the previous year, which was proba-
bly the first of its kind in history. And these two
congresses did indeed constitute a historical event,
because, while many others followed that laid claim to be
in the same mould, those two will remain an increasingly
nostalgic point of reference, a token of a period when
intellectuals professed a naive faith, subsequently so much

decried, in their power to prefer the force of the intellect to that of arms. Gerda, who had been in Spain since May, at first with Capa, then alone, covered the Congress from start to finish, while continuing to make trips to the front to supply *Ce Soir* and *Regards* with photographic reportage, which they often featured prominently on the front page. This was then repeated in the German émigré paper, *Die Volks-Illustrierten* or in *Time*. The participants in the Congress fêted *la pequeña rubia* until late into the night in the bar of the Gran Via, where, among other republican songs, she sang 'The four generals' (which promised that the leaders of the fascist rebellion would be hanged) and would then go back to the front at five o'clock in the morning.

Ever since her first visit to Spain with Capa in August 1936, right at the start of the Civil War, when Barcelona was mobilising to defend itself, Gerda cherished an obsession: finally to be able to report on a republican victory. The news of the assault on Brunete, where Franco's army threatened to cut off the vital route linking Valencia to Madrid, fired her with enthusiasm. She wanted to be the first to publish pictures of victorious republican soldiers and she was: on July 22 *Regards* published her photos, showing them passing in front of the sign BRUNETE, waving their flags, at the end of bayonets, or painting a hammer and sickle on the wall while deleting the picture of the fascist emblem, the cluster of arrows and the fascist war cry: ¡*Arriba Espana!* Caught under gunfire from German aircraft, duly identifiable by their black crosses, she photographed these too, remarking to Claud

Cockburn, 'In case we do somehow get out of this, we'll have something to show the Non-Intervention Committee'.

*

She had decided to return to Paris on July 26 and meet up with Capa, who was busy with preparations for a trip to China with the filmmaker Joris Ivens's team. For the evening before her departure she had spoken of a big farewell party at the Alianza to celebrate her twenty-seventh birthday a few days in advance. At dawn on the 25th she woke her friend Ted Allan to ask him to go out with her on one last expedition to the village of Brunete: she found a car with a French driver. The young Ted Allan, with whom she had travelled to the front several times, was the political commissar to the Canadian doctor, Norman Bethune's medical unit, which specialised in blood transfusions. The driver, frightened, abandoned them outside Brunete and they made the last part of the journey on foot. They went to General Walter's Command Post – his real name was Karol Swierczewski, he was Polish and a former officer in the Red Army who was in charge of the sector. The latter ordered them to leave immediately, along with all the other journalists, because an assault from Franco's forces could come at any minute. But they stayed there, crouched down in a dugout. Gerda went on taking pictures until she had entirely used up her supply of film. The shells, the bursts of machine gun fire and the bombs were getting closer all

the time. They saw the forward lines of the republicans surging back towards them in disarray. They ran, across fields strewn with the dead and wounded, towards the road that led to the village of Villanueva. There they were able to scramble onto a tank, taking several wounded men with them. Further on they encountered General Walter's car, for the moment assigned to the transport of the wounded, heading for Madrid. Extreme confusion prevailed on the road, fugitives and vehicles all mixed up together. Gerda managed to climb onto the running board of the car. At that moment a republican tank of Russian manufacture escaped the control of its driver and hit Gerda sideways on. On the other side Ted Allan was hurled to the ground. His legs paralysed, he heard her crying out without being able to go to her aid. Then some hedge-hopping aircraft flew over and everyone flung themselves into the ditches. When Ted Allan came to, Gerda, her stomach ripped open, holding in her intestines, had already been thrown into an ambulance. At the hospital in El Escorial they gave her a blood transfusion and a morphine injection. 'Incredibly brave,' are the words of the witnesses, the surgeon and others who were perfectly well aware of who she was. All the facts contradict Rafael Alberti's account – it is as if, in recalling the event, he had sought to add melodrama to tragedy.

According to the American nurse who attended to her, 'the only thing she said was: "Are my cameras smashed? They're new. Are they there all right?"'

*

The last photographs Robert Capa took in Indochina in 1954 before stepping on a landmine were developed. As to Gerda's photographs, it is hard to know whether the ones published in the press as her 'last' during the weeks that followed were indeed taken during those hours that preceded her death. It is known that at the hospital she asked for 'her cameras', but I have found no witness who records whether these were rescued. Several moments before the accident she was saying that she had just got her best ever pictures, that she would deliver them to Paris next day but, before that, they would drink some champagne in Madrid. Could it be that she was still confident of victory?

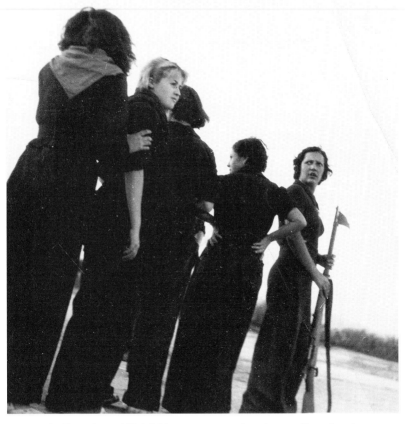

3. Barcelona, 1936. 'Militiawomen on beach near Barcelona'.
Photo: Gerda Taro.

TWO

They wanted to be rich, famous and American

Gerda Taro (or sometimes Gerta Taro) was a name she went under for a little more than a year, from the spring of 1936 to July 1937. And it was only during the last two months that it appeared alone as the byline for her pictures. Up until then her photographs had been published indiscriminately along with those of André Friedmann, over the single byline: 'Capa', and later 'Capa & Taro'. This was the year that coincided with her true career as a photographer. A meteoric career. At the start of 1936 she was still simply the secretary for the Alliance Photo Agency. In 1937, up to her death, *Regards* and *Ce Soir* regularly presented her photo-reportages as 'from our special correspondent.'

Her real name was Gerta Pohorylle. She was born in Stuttgart in 1910. The Pohorylles, a solid middle class Jewish family, comfortably off and to use that detestable word, 'assimilated,' came from Galicia, and were therefore

subjects of the Emperor and King Franz Joseph I. To be of Austro-Hungarian nationality in the Germany of those days was hardly a problem at a time when people travelled about and settled more or less everywhere without difficulty, if they spoke German, particularly in Germanic central Europe. At the end of the Great War, on the other hand, the creation of new frontiers, by the treaties of Versailles, Trianon, Bagatelle and others, created strange situations. Hungarians discovered they were Rumanian, Bulgarians and Turks were transformed into Greeks, Germans into Czechoslovaks, Austrians into Italians, Russians into Poles and more besides. As for the Pohorylles, thanks to their place of origin, they suddenly acquired Polish nationality, Poland being a country whose language they no longer spoke, if indeed they ever had, and which they had left some decades earlier.

Gerta grew up in Leipzig, a city her father was obliged to move to, it was said, as a result of business problems. Business problems or no, she enjoyed a carefree adolescence. She was an excellent student at school, very gifted in the natural sciences and languages. Leipzig was a city where the bourgeoisie had developed a long intellectual tradition. On top of this there was a great surge of freedom rippling through German youth during the Weimar Republic. It was the period of the Wandervögel youth movement, that of the cult of nature and the emancipation of the body and Gerta threw herself into it wholeheartedly. Which did not stop her liking parties, make-up, cigarettes, dancing and tennis. It was at the tennis club that, at the age of seventeen, she met her

first love, Pieter Bote, who was a representative for English cotton mills (some of Capa's biographers would later describe him as 'an English industrialist'). A love so serious that they planned to marry. Was it to put a little distance between them that Gerta was sent to spend the year of 1927 in Geneva, at a high class establishment for girls, the Pension Florissant? Or because the family was anxious about her excessively free and easy ways? Boarding schools, even the gilt-edged ones, are designed, it is well known, to knock a bit of sense into young people who are too emancipated too soon. Indeed Gerta wrote to a girl friend at that time: 'I realize that I am perfectly capable of being in love with two men. I'd be a fool to feel bad about that.' The second man, as it happens, was the young Georg Kuritzkes, who was embarking on his medical studies and with whom, throughout her life, despite their being exiled in different countries and despite people she met later, she would continue to maintain an affectionate and confiding friendship. And as for Georg, he may not have been an 'English industrialist', but he was a young man with plenty of sense already. He very quickly understood the dangers of the rise of Nazism; very early he decided to fight against it. It ran in the family: his father was known as 'the red doctor' and his mother, Dinah Geibke, has been described as 'a revolutionary', who had known Lenin in Switzerland in 1912.

I assume it was in Geneva that Gerta acquired her fluency in French. She already spoke perfect English with only 'a slight accent', as a British journalist she met in

Spain would later observe. I'm certainly prepared to wager that she perfected her tennis there.

On January 30 1933 Hitler came to power, democratically elected by the majority of the German people. On March 19 Gerta, who would soon be twenty-three was arrested and imprisoned in Leipzig. She was suspected of having taken part in the distribution of anti-Nazi leaflets issued by the RGO, the acronym of the Revolutionäre Gewerkschafts-Opposition, the Revolutionary Trades Union Opposition, a mass movement with ties to the Communist Party. These leaflets were the pretext for wide ranging raids by the SA, the assault sections of the Nazi Party, which had arrived to bring the city into line with Nazism. It was the start of the terror. But to move on from this to assert, later on, that Gerta herself belonged to the Communist Party is to take a step further, something which some of Robert Capa's biographers have not hesitated to do when speaking of her and her purported influence on him. What is certain is that the milieu Gerta grew up in immediately strove to resist the Nazis. But too late, as we know. It was difficult to create a common front after the suicidal rivalry which, during the preceding years, had brought German socialists and communists into conflict, to the point of neglecting the danger of the Hitlerite enemy, which, for its part made no distinction between them. This was the sad result of the 'class against class' diktat issued by the Comintern in Moscow. A real gadarene stampede. In 1933 Nazi repression targeted all democratic movements indiscriminately, whether they were 'of the left' or conservative, including

student societies and even groups of nature lovers, accusing all of them, for good measure, of being associated with 'international Jewry'. Only the National Socialist party had free rein.

Gerta was 'of the left': everything in the education she had received from her parents, a secular education, along Enlightenment lines and even, though at one remove, in the Jewish messianic tradition, predisposed her to believe in a better future, a freer and more equal society, the abolition of differences. It is also logical, knowing the commitment Georg Kuritzkes had made and the confidence she had in this dear friend of hers, to conclude that for her 'the left' meant the Communist Party in particular, since it had placed itself at the head of the fight against clearly defined enemies: racism, fascism and dictatorship. But this is not sufficient to make of her an active communist, involved with meetings, discipline and organized work.

We have a first hand account of her time in prison discovered by her biographer, Irme Schaber. A fellow prisoner, Herta H., has described her sensational arrival in the cell crammed with women. Gerta immediately apologized for her clothes: 'You see, it's because the SA arrested me just as I was about to go out dancing.' Her father was able to get cigarettes in to her, which she shared out immediately. She amused her fellow prisoners by teaching them several words of French and English. She sang them American songs. In a trice she became the *Liebling*, the darling, of the women prisoners.

So was she just a charming little entertainer, whose merry laughter melted even the surliest of the prison

warders? writes Herta H. One night, when they heard terrible cries coming from the men's quarters, she revealed another side. 'Suddenly, woken up in the dark, we sat up in silence on our mattresses with beating hearts: beneath us the Gestapo were assaulting our comrades. There was a bell beside the door we were forbidden to use. "Let's ring it," said Gerta. The strident alarm resounded throughout the building. We unleashed a real storm, and the warders came and threatened us.' Herta H. also recounts that it was thanks to Gerta that, 'for the first time under Hitler the alphabet of knocking on the wall made its appearance in the women's section of that prison.' It was she who taught her comrades how to communicate with neighbouring cells.

What probably impressed Herta H. the most was her cellmate's acting ability. 'We were both at the mercy of the same police investigator. I noticed that this man, with his cynical smile . . . had one failing: he couldn't bear to see a woman cry. I had told Gerta about it. This man certainly didn't have the sole power of decision but he could speed up our release. So maybe we could exploit his weakness.' Gerta threw herself into it wholeheartedly: under interrogation she systematically turned herself into a fountain. 'So you can do it just like that, can you?' asked Herta. 'You can weep at will?'

'Of course. Any time I need to,' replied Gerta, with her pretty, mischievous smile.

It may well have been in prison that Gerta Pohorylle first discovered, as others have found, that we all carry within us a portion of invincible liberty.

The real reason for her arrest was that her two brothers actually did belong to the Revolutionary Trades Union Opposition. The SA were unable to find them and they wanted to use Gerta as a means of blackmail, hoping they would give themselves up. But they took good care not to appear: Dachau, the first of the death camps, was already filling up. And if she was released after seventeen days, it was thanks to her Polish passport. Her parents, horrified, had at once alerted the Polish consul and the latter, to his credit, disregarding the deep-rooted anti-Semitism of his fellow citizens, had intervened. Quoted by Irme Schaber, the report by the Reichskommissar for the Province of Saxony, addressed to the Polish consulate ran as follows:

> During the search carried out at the domicile of the parents of Fraülein Gerta Pohorylle a signed membership card for the RGO, which is a communist organization, was found. A letter contained an exchange of ideas about communism. After her imprisonment Fraülein Pohorylle explained that the signature was not hers. An examination nevertheless showed that a doubt remains. Fraülein Gerta Pohorylle's brother is well known to be active in RGO circles. He has been missing for some time. Be that as it may, Fraülein Gerta Pohorylle has made no complaint of any ill-treatment, either at hearings by our services, or in the course of being questioned in prison.

Although this rescue, thanks to her Polish passport, is perfectly logical – in Germany in 1933 the Nazis were still

obliged to respect certain protocols vis-à-vis foreign powers – this has not stopped Capa's biographers from jumping to conclusions. According to Alex Kershaw, author of *Blood and Champagne, The Life and Times of Robert Capa*, from 1933 onwards she was 'already an active member of communist organizations.' For how else could the woman who, in the words of Richard Whelan, author of *Robert Capa* (published by Faber and Faber in 1985), was the daughter of 'a Yugoslavian Jew', who had 'established a wholesale egg and vegetable business' in Leipzig and 'attended a commercial school and learned secretarial skills', have obtained something as unusual and miraculous as a Polish passport, if it were not thanks to a powerful secret organization, namely the Communist Party, or indeed the Comintern?

By the end of the summer of 1933, Gerta was in Paris with her friend Ruth Cerf, having made a detour via Italy to meet up with Georg Kuritzkes for several days. She would return there again whenever she had the means to pay for a third class ticket, in summer to visit Pisa and Florence with him and in winter to go skiing. That famous Polish passport allowed her to cross the frontier without any difficulty. But there was certainly no question of her now living, as the old German adage has it, *glücklich wie Gott in Frankreich*, as happy as God in France, especially since France was rife with unemployment, nationalist leagues and the rise of xenophobia. Nevertheless she was fluent in French, Paris was the cultural capital of the world and most of central Europe's anti-Nazi intelligentsia had taken refuge there.

Difficult beginnings. Hard times. A position in a French family for a time, as something like an au pair girl. A shared room. The search for little jobs on the black economy. Gerta worked as a typist for an Austrian psychoanalyst, Ruth as secretary to a German writer, a friend of Max Ophüls, who was writing a biography of the Countess Walewska. She also posed for photographs. A few meagre contributions came in from Gerta's family, who were still waiting to emigrate. To this was added help from an old friend, Willi Chardack, who was studying medicine in Paris and with whom she would live briefly. Also from Pieter Bote, her ex-fiancé, and from other émigrés or social circles that supported them. Clara Malraux remembered helping Gerta to find temporary accommodation. They moved from maids' rooms to hotel rooms, to temporary lodgings with friends.

Whatever people may say, starving to death if you are an isolated wanderer, lost in a hostile city, without friends or family, with no past and no future, is not the same as being an émigré from a middle class family, with a knowledge of several languages, a network of friends and a gift for making new ones, some of whom belong, or will belong, among the greatest names in twentieth-century culture. Above all when you are upheld by the optimistic belief that all this will pass, that the Hitlerite madness will only last for a time, that order will soon be restored. This does not relieve immediate worries, without a sou to pay the rent or even the price of a meal, but it does make it possible not to lose faith in the future. Especially if that faith is shared by countless others in the same situation.

The most tenuous signals from abroad reinforced their conviction that National Socialism could not prevail for long. In the first place the fiasco of the Dimitrov trial in Germany, which covered the new masters in ridicule, and subsequently the Roehm Putsch, in which Hitler and his henchmen eliminated the leaders of the SA, who had become useless and dangerous to them, both of these were interpreted as so many omens of an imminent collapse.

A vast, warm extended family gathered at its favourite cafés, the Capoulade on the Boulevard Saint-Michel, the Dôme on the Boulevard Montparnasse. It was a time of intense artistic, literary and political activity on the part of the émigrés in Paris, where big names like Walter Benjamin and Joseph Roth mingled with less well known ones. At the Capoulade, the café Gerta preferred to frequent, people of diverse opinions rubbed shoulders and argued. A diversity stretching all the way from the KPD, the German Communist Party, to the SPD, the German Socialist Party, via all the nuances of anti-Nazism, the SAPD, the anti-Stalinist German Socialist Workers' Party, the Trotskyists, the Anarchists and the KPO, the Kommunistische Partei-Opposition (to the left of the Communist Party). The future Federal Chancellor Willi Brandt, a Socialist Party activist who had come from Norway, could be met there, as could Arthur Koestler, at that time a secret agent of the Comintern, assigned to propaganda. The latter recalled that Gerta had nothing in common with the two types of women who abounded in the German Communist Party: pretty, brazen women from the working class and neurotic killjoys from the

bourgeoisie. It was probably following the example of Ruth, who was the more convinced of the two – though her recollection was that she and Gerta were 'very little committed' – that Gerta went to evening classes at the Freie Deutsche Hochschule, the Free German College of further education, where, as an unregistered student and 'sympathiser', she studied the rudiments of Marxist-Leninism. She also decided to attend courses in physics on the same basis. She frequented the Schutzverband Deutscher Schriftsteller, the Protective Association for German Writers in Exile, which met at the Café Mephisto on the Boulevard Saint Germain. There she might have come across Bertolt Brecht, Anna Seghers, Ergon Erwin Kisch, Franz Hessel, John Heartfield or Louis Aragon and Paul Nizan.

But there should be no mistake. A family, perhaps, warm, to a certain extent, but, like all families, harbouring not just resentments but often inexplicable hatreds. Exile can be a bond, especially when all are joined in the struggle against a common enemy as formidable as Nazism. But every emigration also creates a cultural ferment both for better and for worse. At the time of the Moscow show trials everyone was called upon to take sides: those who were not admirers of the Soviet Union quickly risked being labelled 'enemies of the working class', or 'Hitlero-Trotskyists' and other choice epithets, which for some would turn out to be lethal. But in her own friendships Gerta seems to have paid little heed to such blanket condemnations.

In September 1934 she met the young Hungarian

photographer – he was three years her junior – André Friedmann, who had gallicized his Christian name, Endre. He had escaped from Horthy's dictatorship after being imprisoned. He had come via Vienna and then Berlin, where he worked for the Dephot agency, run by the Hungarian Simon Guttmann, the first agency entirely devoted to the growing field of photo-journalism. Initially he was more of a technician-of-all-work – including stoking the boiler – than a photographer. However Simon Guttmann must have had faith in him since, one day when there was no one else available, he sent him out to do some photo-reportage. This enabled Endre to get himself noticed with some sensational pictures of Trotsky, taken when the latter was speaking in Copenhagen. Trotsky did not allow photographers and he had to work stealthily. Significantly, this was the first public meeting at which the exile had addressed a western audience.

Following his arrival in Paris in 1933, André Friedmann lived from hand to mouth. Legend has it that he even went fishing in the Seine in order to feed himself. His friends at that time were André Kertész (to whom he owed a great deal, both materially and professionally), Gisèle Freund, Hans Namuth, David Szymin, alias 'David Seymour', alias 'Chim' (a Polish Jew, like him, and living in a similar plight) and Henri Cartier-Bresson, an upper middle class Frenchman who had come from the surrealist movement. They were united by their enthusiasm for the fresh possibilities opened up by this new instrument, the Leica camera. But all this does not necessarily keep body and soul together. André struggled to place his

pictures – when he was not obliged to pawn his camera at the Mont-de-Piété. He had worked in the employ of one of the first photojournalists won over to the Leica, Hug Block, notably covering the riots in Paris on February 6 1934, but it was his employer who took credit for the pictures.

André Friedmann was looking for a young woman who would agree to pose for an advertising brochure for a Swiss insurance company, a commission from Simon Guttmann, who, now exiled himself, was attempting to survive with a small agency. He is said to have noticed Ruth Cerf at the Café du Dôme and asked if she would act as a model. Since Ruth Cerf had already posed for photographs following her arrival in Paris, this may not, in fact, have been the result of a chance encounter, as related by the Capa legend. At all events the appearance of this seductive but extremely scruffy young man – he had, as she, like many others, related – the charm and easy grace of a gypsy – inspired only moderate confidence in Ruth. Apparently she agreed but came to the rendezvous in the company of her friend, Gerta.

It was in the course of the summer of 1935 that Gerta and André became lovers. Returning from an assignment in Spain financed by Guttmann, during the course of which he encountered a famous astronaut who had broken records with his balloon, André met up with Gerta and a group of friends, including Willi Chardak, camping on the Ile de Sainte-Marguerite on the Côte d'Azur.

André and Gerta were young and beautiful, they were

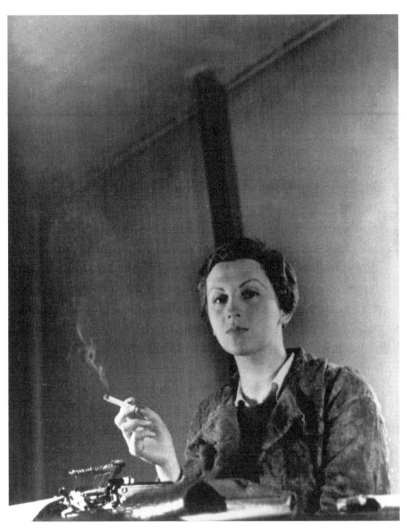

4. Paris, 1935.
Photograph by Fred Stein.

independence personified. They loved gambling, including gambling with their own lives, as both were to prove. They naturally seduced everyone they met. They resembled one another in many ways. My own view is that any man reading an account of André's life (or, at least, the version of it that he chose to recount himself) must feel a twinge of regret at not being Robert Capa. And that any woman contemplating Gerta's life must also occasionally experience a longing, however slight, to have been Gerda Taro. At any rate, I should welcome it – as would others, I hope – if every woman had something of Gerda about her.

In speaking of André Friedmann, the future Robert Capa, Ruth Cerf would say: 'There was nothing he couldn't do.' Henri Cartier-Bresson speaks of 'a poker player', who 'used to wear a bullfighter's outfit like a great torero, but was one who did not kill: a great gambler, who fought valiantly, like a whirlwind, both for others and for himself.' Much later John Steinbeck, who had been his travelling companion, was to say: 'It is very hard to think of being without Capa.' For him the 'torero' was not only not a killer, but 'his work is itself the picture of a great heart and an overwhelming compassion.' For Irwin Shaw he was 'worldly, handsome, languid, and dandyish when it suited him . . .' And for Pierre Gassmann, the friend who, when they were living from hand to mouth, used to develop photos by André Friedmann, Chim and Cartier-Bresson in his bidet: 'From the moment I met him until he died he was always great fun, always very much one to live for the moment, always passionate about life –

especially food, wine and women. He was very instinctive, a very natural photographer. He wanted to show people things they had never seen.' Martha Gellhorn, a journalist at *Colliers Weekly*, who met him in Valencia in 1937 and saw him again in 1939, the year in which she became Hemingway's wife, regarded him as a kind of brother, one of those rare men who have come to terms with their contradictions and their passions. In one of her novels she drew a portrait of him under the name 'Bara', evoking his look of a gypsy, always on the alert, worshipped by women, liked by men, electrifying. The type you boast of having known, even when it's not true, and about whom stories are made up. Someone people quote. Someone you are proud to be seen with and eager to do favours for.

Of Gerta Pohorylle, the future Gerda Taro, Irme Schaber would write in her biography that the seductive effect she had 'did not simply derive from her feminine beauty. She was an intelligent and cultivated woman who made an impression by her natural manner, her spontaneity.' In writing this, Schaber was eager to give the lie to some accounts, emanating especially from women, which present Gerta as incapable of deep and disinterested love. But if that had been the case, what 'interest' could the André Friedmann of 1934 have presented, penniless and badly dressed as he was and with no permanent job? Her best friend, Ruth Cerf, is said to have reproached her with being too fickle, constantly flitting from man to man, in other words, with having been a flirt. Could it be that this judgment, severe from the point of view of conventional morality, had its roots in a strange

post-mortem jealousy. We seem to catch a fleeting glimpse of the ghost of Helen in Jean Giraudoux's play *The Trojan War Will not Take Place,* staged at about that time: 'You don't love Paris particularly, Helen. You love men!'

'I don't dislike them. They're as pleasant as soap and a sponge and warm water; you feel cleansed and refreshed by them . . .'

For my part, I will say that the two of them, André and Gerta, were both simply free spirits, and intensely so.

The period that followed saw them living together, separating, being reunited, without ever losing touch with one another. Gerta lived for a time at the home of a German émigré lawyer, Fred Stein, who had decided to take up photography and would be remarkably successful. (The fine picture of André and Gerta together is his.) He developed his films in the bathroom and it was there, it seems, that she learned the rudiments of work in the dark room. This experience, as well as that of spending time with André, who made her work with him, gave her an idea for a sure means of regularizing her situation vis-à-vis the French authorities: to present herself as practising the recognised profession of photographer. André, for his part, seriously considered abandoning photography. He was tempted by a career as a film actor – but he received several commissions and made progress in selling his work. Amongst other things he carried out a reportage on a parachute school for a Japanese agency to whom he had been recommended by his friends Hiroshi Kawazoe and Seiichi Inouye, whose lodgings he shared for a time. His photographs were bought by the *Berliner*

Illustrierte Zeitung. This magazine had been confiscated by the Nazis, along with the whole of the Ullstein group, as being 'thoroughly Jewish'. They were now using it as a propaganda vehicle. But the state of André's finances did not allow him to be choosy. Nevertheless, he signed these photographs with his first name only, in order to conceal his telltale surname. He was also starting to sell his photographs to the most prestigious illustrated magazine of the period: *Vu.*

In October 1935 Gerta finally obtained fixed employment and not just any old job: at the Alliance Agency run by Maria Eisner, whom André had probably known in Berlin and who was only just recovering from the collapse of a first venture, the Anglo-Continental Agency. For a year Gerta would be its king pin: speaking three languages, she wrote captions, negotiated with clients throughout the world and perfected her printing skills. It is not surprising that subsequently in Madrid she would be able to pass these on to Rafael Alberti. From this time onwards André and Gerta were more comfortably off, could rent a flat and live together. She, whose elegance has always been remarked on, even at her most impoverished, instructed André in the art of dressing like a dandy. He took little persuading.

They were ambitious. Determined to conquer Paris and the world. André never concealed the fact that he wanted to be 'rich, famous, fascinating and American.' A big-time gambler in the mould of Scott Fitzgerald's Gatsby. Was that Gerta's ambition too, or was there something else? At all events, she it was who at the

beginning of 1936 had an apparently crazy idea but one which turned out to be a stroke of genius. Here we are moving into the territory of legend. We only have the account given by André, who was never beyond inventing things, and several of his close friends, who themselves only knew what he chose to tell them.

It was a gamble well in character for both of them: to invent the persona of an American photographer, rich and famous on the other side of the Atlantic – exactly André's own dream – who had come to work in Europe for a time. Expensive, naturally. Much more expensive than the hack photographer, André Friedmann. André's function would be to take the photographs, and she to sell them, thanks to the contacts and experience she had built up at the Alliance Agency.

This character had to be given a name: it was to be Robert Capa, Bob Capa for short. And here the versions, or rather the speculations about the origins of the name enter the realms of fantasy. The most prevalent is that they took inspiration from the name of the film director Frank Capra, the archetype of Hollywood success: his films were popular throughout the world. *It Happened One Night* had just carried off three Oscars. Capa himself later lent support to this theory by recounting how in 1942, on the warship taking him from the United States to England, the Captain mistook him for Capra and obliged him every evening to regale him with the latest Hollywood gossip. Scrupulous biographers have mentioned the meaning of the name in Hungarian: Richard Whelan cites it as meaning 'pick'. In the catalogue of the

Bibliothèque Nationale de France it is given as 'shark'. And for Jean Lacouture, (who never lacks imagination), 'sword'. There is indeed a word *'capa'*, which means 'shark', and another word *'kappa'*, meaning 'hoe', which is not far from 'pick'. However in Hungarian 'c' is pronounced 'ts'. Phonetically this would give 'tsapa', which knocks out the shark. At all events, whichever way it is translated, it is hard to see where all this leads, except possibly for the poetic 'sword' . . .

What is certain is that changing his name was not some kind of innocent game. In the climate of French xenophobia the name 'André Friedmann', combined with a less than perfect pronunciation of French, had a foreign ring to it, German and, still worse, Jewish. Besides, there was another photographer called Friedmann. 'Capa' was versatile. Better still, it was universal. The origins of André Friedmann, like those of Gerta Pohorylle, could more or less be placed. Robert Capa was much harder to place. It could be Spanish, Italian (Frank Capra was born in Sicily), or equally well: French, American or from Greenland . . . So, even if the name might be foreign, it was not evocative of the 'mongrel races' whom Charles Maurras and *Action Française* were currently accusing of coming and besmirching French soil by bringing in filth on the soles of their feet. Or, not to beat about the bush, it was neither *'boche'* ('hun') nor *'youpin'* ('yid'), two choice epithets which caused a lot of doors to slam in your face in Paris at that time. Right up to the day in 1939 when, in its abysmal stupidity, the Daladier government imprisoned in concentration camps all the

anti-fascist German émigrés, with Jews at the head of them, treating as 'enemy agents' those who had trusted it and could be its most passionate defenders against the Nazi threat.

What it all amounted to, in essence, was a farewell to any fixed point in the world, to any country André and Gerta could claim as their own or to which they could dream of returning one day. Capa's life would bear witness to this: he would only make brief return visits to Hungary and he would never have a permanent address. Just those of bars and hotels in principal cities, where he stayed from time to time. And if he was not yet rich and famous, he already chose to pass for American, because the United States was, *par excellence*, the land of the melting-pot where all names rubbed shoulders. More of a gypsy than a Jew in his wanderings, this was the gesture with which he burned his bridges. Having been born, as his brother Cornell would write, 'without any chance of travelling or speaking a language unknown beyond the frontiers of one small country, he succeeded in getting to know the entire world thanks to a universal language, photography. Thanks to this he could speak to everyone.'

What is certain, too, is that the ruse worked. Not for everyone, but even so. Legend again has it that before publishing a major reportage by Capa – and paying him at the new rate – Lucien Vogel, the editor of *Vu*, telephoned Gerta: 'This is all very interesting about Robert Capa, but tell that ridiculous boy Friedmann, who goes around shooting pictures in a dirty leather jacket, to report to my office at nine tomorrow morning.'

What is quite certain is that in that year, which saw the birth of the Front Populaire in France and the League of Nations in crisis, whether he was known as Friedmann or Capa, André, now Robert, had plenty on his plate: he brought in some sensational photo-reportages, and Lucien Vogel was pleased with him. The new communist paper, *Ce Soir*, run by Louis Aragon and Jean-Richard Bloch would be calling on him more and more often, as would the communist weekly *Regards*. Maria Eisner, who was not fooled either, engaged him at a fixed salary with an obligation to submit three picture stories per month and Gerta was selling his photographs abroad. In a word, within a few months Robert Capa became a photojournalist well regarded in the field as well as one whose photographs, along with those of Cartier-Bresson, would remain among the most vivid records of the euphoria of the Front Populaire.

At the same time and for similar reasons Gerta also changed her name. From now on she would be Gerda Taro. Here too there has been speculation: the name may have been inspired by that of Greta Garbo . . . The catalogue for the Capa exhibition at the Bibliothèque Nationale attributes this borrowing of 'Taro' to 'a young Japanese artist, a sculptor, Taro Okamoto, who was living in Paris at the time and was a woman friend of the couple.' Which is all very well, except that Taro Okamoto was a man, a figurative painter, known in Montparnasse as 'la Baleine' (the whale) on account of his great girth.

Capa was eager to cover the Abyssinian war launched by Mussolini. But when Franco's uprising erupted in

Spain in July 1936 Lucien Vogel immediately wanted photographs for a special number of *Vu*. He chartered a small aircraft to send a team to Barcelona. Gerda and Bob boarded it, also notable in the party was David 'Chim' Seymour. The couple worked together. Both of them signed their pictures 'Capa' without distinction. They had two cameras, a Rolleiflex and a Leica. It seems that she preferred to use the former and he the latter. But nothing is absolutely certain and this single signature created a confusion, increased by Capa's death in 1954 – which has prevailed for almost sixty years.

The plane crash-landed outside Barcelona. Unharmed, the passengers arrived at the Catalan capital which was in complete ferment. This was August 5th. An attack by the rebel forces was expected at any moment. 'What prevailed there', wrote the German writer, Gustav Regler, who became a political commissar in the International Brigades, 'was a contagious intoxication, a thirst for self sacrifice, an uncompromising belief in liberty.' Arriving there at the end of that year, George Orwell would later evoke this period 'when generous gestures and sentiments were easier than they ordinarily are ... Shabby clothes and gay coloured revolutionary posters, the universal use of the word "comrade", the anti-fascist ballads printed on flimsy paper and sold for a penny, the phrases like "international proletarian solidarity" pathetically repeated by ignorant men who believed them to mean something ...'

They photographed the crowds in the street, the barricades, the hasty formation of militias, the anxious and fervent faces of the militiamen dressed in *mono azul* – the

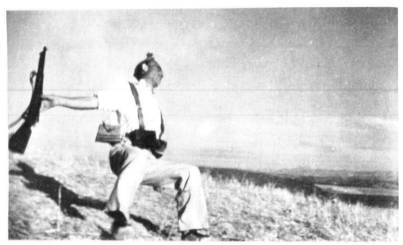

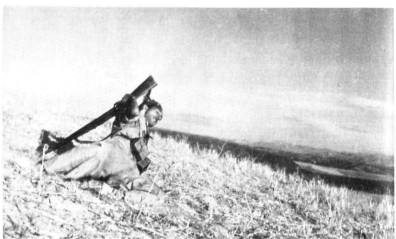

5. Cerro Muriano, September 5 1936. Original publication in *Vu*,
September 23, 1936.
Photos: Robert Capa.

workers' blue overalls, in the absence of uniforms. Gerda was enthused by the armed women's detachment of the PSUC – Partit Socialista Unificat de Catalunya – and the still somewhat awkward photograph she took of them, appeared in *Regards*. Several of Capa's photos, such as that of the militiamen of the Union de los Hermanos Proletarios – the anarcho-syndicalist Union of Proletarian Brothers – setting off by train for the Aragón front, would go all round the world.

In mid-August they left Barcelona for the front. They travelled via farms that had become collectives, following the expropriation of the big landed proprietors, and joined the Centurie Thaelman, the embryonic form of the International Brigades. They followed a column of the POUM – the libertarian and Trotskyist Partido Obrero de Unificación Marxista – and headed for Madrid, which was under threat. For a time they were present at the siege of the Alcazar fortress at Toledo by the republicans. On September 5 they were in the village of Cerro Muriano, where they took pictures of the inhabitants terrorized by an air raid.

That was the day when Capa took what, along with those pictures of his of the Normandy Landings that have survived, was his most famous photograph. A militiaman, launching into an attack, struck head-on by a bullet. Much has been written about it. Not only comparing it to Picasso's 'Guernica', but discussing in endless detail the circumstances in which it was taken. Was this a real death or was it staged? In the sixties an English journalist, a former correspondent for the *Daily Express*, claimed that

Capa himself had confided to him that the whole thing was a fake. But in 1996 it was announced in the press, on the sixtieth anniversary of 'the photograph that symbolizes the Spanish Civil War', that the 'unknown militiaman' had been identified, thanks to the notebooks of one of his former comrades, an amateur historian who had recently died. He was a certain Federico Borrel Garcia, aged twenty-four, an active member of the anarchist workers' federation, the CNT (Confederación Nacional de Trabajo). Capa himself always asserted its authenticity and gave numerous accounts of it, which unfortunately differ. At the time his book, *Slightly Out of Focus,* was published in 1947 he gave the following account. He was in a trench with a score of militiamen, facing a hill held by the enemy. These men were not soldiers and time and again they would die with grand gestures, in a state of exaltation. 'Sure enough the machine gun opened up and, dim dom! . . . And after five minutes again they say: 'Vamos!' and they got mowed down again . . . The fourth time I just kind of put my camera above my head and even didn't look and clicked a picture when they moved over the trench.'

It is impossible to reconstitute the sequence in which the shots were taken, as the negative of the roll of film and the contact sheets are lost. When they were published in *Vu* the photograph presented as the second in the sequence shows the man, struck down, collapsing on the ground, but close study would have revealed that it is not the same man. This is confirmed by the plural used in the headline above the two photos: 'How they fell.' A

headline followed by a caption which is hardly illuminating and even, with the lapse of time, frankly devastating: 'Legs tense, chest to the wind, rifle in hand, they tear down the stubble-covered slope . . . Suddenly their flight is broken, a bullet whistles – a fratricidal bullet – and their blood is drunk by their native soil.' Finally, and for good measure, Ted Allan claimed that their friend Chim later confided to him that he could not remember whether this photo was taken by Capa, by himself or by Gerda . . . If one sets aside this last piece of 'evidence', as being second hand and possibly spoken in drink, then common sense and experience must have their say. Raymond Depardon, who lacks neither, has reasonably observed that nothing would have compelled the photographer to use a low angle shot, actually positioned below the militiaman's feet – unless the person who took it was in the logical position of someone hiding in his dugout as best he could and obliged to hold the camera up in the air so as to avoid being picked off like a sitting duck himself.

Finally, one may wonder why, having come there with the intention of showing republican victories at all costs, Capa and Gerda would have taken so much trouble first to stage a death, albeit a heroic one, and then stubbornly to circulate this image of a corpse fallen to the ground. Throughout his career Capa never had much of an appetite for corpses. Gerda had fewer qualms about this but they tended to be the bodies of victims, women, children, evocative of the enemy's brutality, rather than those of fighters, evocative of defeat. It also seems likely that Capa did not initially attach any special importance to

this picture among all those he took back with him to Paris. The professionals describe him as extremely voluble and, in particular, extremely attached to his photographs, recounting the stories behind them in detail, playing an active part in selecting certain pictures and hotly defending his choices. The picture of the militiaman struck down made its way into the international press on its own, starting from its publication in *Vu*. It only became really celebrated much later when it was reproduced on a full page in *Life* and in *Paris Soir,* to accompany a text by Antoine Saint-Exupéry.

At the end of September Gerda and Bob returned to Paris, travelling via Barcelona. Capa at once began covering communist rallies and the Congress of the radical socialist party, sending pictures to Strasbourg. Commissioned to produce a cover picture for *Regards* to illustrate an article on 'The Tragic Fate of Fallen Women' and not having a fallen woman to hand – for it is hard to imagine a prostitute agreeing to see her face blazoned across hundreds of newsstands – he was not put off his stroke. Gerda posed for him, adopting an appropriately tragic demeanour. Too tragic indeed: the picture is pure melodrama. It would make a good illustration for *La Dame aux Camelias (The Lady of the Camelias).* And there we see it again: she has her hand in front of her face, badly containing her mirth: it's a good joke.

In November Capa returned to Madrid on his own. The besieged city was under assault from incendiary bombs. The situation was desperate. It would be saved at the eleventh hour by the arrival of the International

Brigade. He photographed the fighting at the city gates to the west, with the Thaelman Century, now a battalion, and at the University City, with the French and Belgian volunteers of the Commune de Paris company. He also made a point of taking pictures of the people of Madrid, some roaming about without shelter, peering up at the sky, their faces distraught; the refugees; the ruins; the crowds at the metro stations seeking to escape the bombing. On his return to Paris at the beginning of December *Regards* headed his coverage: 'The capital crucified: amazing pictures taken by Capa, our special correspondent in Madrid.' In January 1937 he made another rapid visit to the Spanish capital, which had succeeded in loosening the stranglehold. Again without Gerda. She was to reproach him for this. All who knew them agree in saying that Gerda encouraged Capa to put himself on the line, to take risks. But she was not a woman to leave him to take them on his own.

In February 1937 they set off again for Andalucía. It is at this time that the credit: *'Photo Capa et Taro'* appears on the rubber stamp with which the prints are signed. It is also at this time that the establishing of a new distance between the two of them can be observed. Gerda had no use, it seems, for Capa's proposals of marriage. She wanted to remain a free agent, his partner, his equal in all fields, including love: not his wife, at a time when civil codes, whether French or any others, contained provisions along the lines of: 'A wife owes her husband respect and obedience.' She it was who had invented the persona of Robert Capa and the game had succeeded beyond all

expectations, but it was not for nothing that she had invented that of Gerda Taro as well. There would come a time for Gerda Taro, too, to exist entirely on her own.

They photographed the survivors of the veritable walk to the scaffold undergone by the people of Málaga, in their flight from the advance of Franco's troops, bombed mercilessly along the road. From there they made their way to the front on the Jarama river, and thence to Madrid. Capa left Gerda alone there, having been called to Paris, where Louis Aragon was offering him the post of director of photography on the new daily, *Ce Soir*.

They met again in Paris in March and set off once more for Madrid the following month. At the Hotel Florida they got to know Joris Ivens who was filming *The Spanish Earth*, Ernest Hemingway, and John Dos Passos. The meeting with Joris Ivens was important for Capa: it led to his future trip to China as part of the crew filming what was to be *The Four Hundred Million*. The encounter with Dos Passos was equally significant for Gerda, but in a different way. On one of his innumerable nights of reminiscence Capa would later speak of her immense admiration for Dos Passos, claiming that she had learned English from *Nineteen nineteen,* his novel about John Reed. She was overwhelmed by it, he said, and began a new life. Since we know that Gerta Pohorylle spoke perfect English as a result of having learned it from her early years, it is hard to see what part Dos Passos might have had to play in this learning process. However the notion that she had been overwhelmed by his book allows us to glimpse an unusual aspect of Gerda Taro.

Nineteen nineteen is the second novel, a sequel to *The 42nd Parallel*, in which Dos Passos intersperses his narrative with brief passages, almost newsflashes which he calls 'The camera eye'. A revolutionary technique for the period. Had Gerda conceived of the ambition (for herself and Capa) of being a 'camera eye'? Capa's mention of the novel about John Reed is thus highly significant. Read by Gerda at the age of twenty-two, which was her age when *Nineteen nineteen* appeared, this text, headed 'PLAYBOY', is more than a political programme: it is a programme for life.

> Reed was . . . husky greedy had an appetite for everything; a man's got to like many things in his life.
>
> Reed was a man; he liked men he liked women he liked eating and writing and foggy nights and drinking and foggy nights and swimming and football and rhymed verse . . .

> Life, liberty, the pursuit of happiness; not much of that round the silkmills when in 1913,
>
> he went over to Patterson to write up the strike, the textile workers parading beaten up by the cops, the strikers in jail; before he knew it he was a striker parading beaten up by the cops in jail . . .

> . . . He learned the hope of a new society where nobody would be out of luck,
>
> Why not revolution?

. . . The war was a blast that blew out all the Diogenes lanterns; the good men began to gang up to call for machineguns. Jack Reed was the last in the great race of warcorrespondents who ducked under censorship and risked their skins for a story. Jack Reed was the best American writer of his time, if anybody wanted to know about the war they could have read about it in the articles he wrote . . .

The World's no fun anymore,
only machinegunfire and arson,
starvation lice bedbugs cholera typhus. . .

. . . A man has to do many things in his life.
 Reed was a Westerner words meant what they said.

John Reed (known to his friends as Jack), who was ready to risk his skin for a story, died in 1920, at the age of thirty-three, in the heart of the Soviet Union, on the way back from the Congress of Peoples of the East at Baku. Gerda, who was ready to risk her skin for a photograph, died at the age of twenty-seven in the heart of Spain, on the way back from the front. If indeed there was any admiration there, she can be said to have been faithful to the end.

It was at the Hotel Florida that Hemingway said he had written his play, *The Fifth Column* a few months later. 'There were three major offensives in the fall and early winter of 1937 . . . projects for the army of the Centre that year. One of them was Brunete, it had been fought, had started brilliantly and ended in a very bloody and undecisive

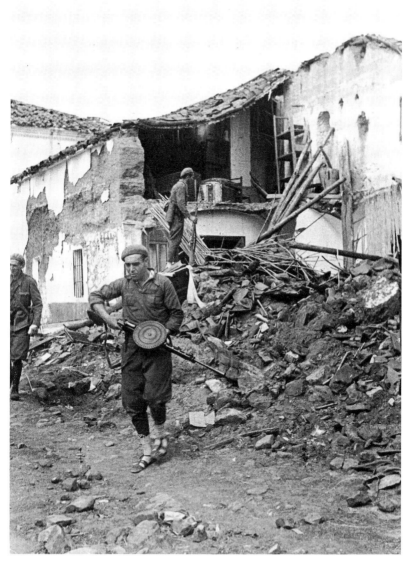

6. La Granjuela, June 1937.
Photo: Gerda Taro.

battle . . . Every day we were shelled by the guns . . . and while I was writing the play the Hotel Florida . . . was struck by more than thirty high explosive shells.'

The principal female character in the play, Dorothy Bridges, a 'tall, handsome blonde girl,' gives an idea of what Hemingway might have thought about the presence of a woman among the war correspondents: 'Dorothy in the rest room is trying on a silver fox cape before the mirror . . . She takes a last look at the cape in the mirror. She is very beautiful in it . . .' 'I'd like to marry her', says Philip, the play's hero, 'because she's got the longest, smoothest, straightest legs in the world, and I don't have to listen to her when she talks if it doesn't make too good sense . . . I just like to hear her talk. I don't care what she says. I'm relaxed now, you see.' Hemingway was said to have modelled her on his companion, Martha Gellhorn. One can imagine that Gerda might have had some reservations about the manly friendship that sprang up at once between Capa and Hemingway.

Their return to Paris, in time to see the largest May Day procession ever, would turn out to be Gerda's last visit to France. May the first was the occasion for a monster demonstration by the Front Populaire, which would not have another one for a long time. But she would never know that. In the photograph taken by Capa, Gerda is radiant. Perhaps, in the cries repeated by hundreds of thousands of voices, 'Fascism will not pass,' she could hear a kind of confirmation that over there in Spain, as in France that day and in Germany tomorrow, victory was still possible.

At all events, her stay in Paris was a brief one. From

now on it was as if her whole life was in Spain. With the people she photographed in the streets; with the volunteers from the International Brigades she encountered at the front each day; with the greatest war correspondents of the age, whom she met up with in the evening, after daylight hours spent sharing with them the dangers of reporting military action. Herbert Matthews of the *New York Times*, Claud Cockburn of the *Daily Worker*, Mikhail Koltsov of *Pravda* and dozens of others.

Capa asked to be released from his contract with *Ce Soir*. He continued to publish pictures there but he was tired of being sent into the depths of France to cover events he considered trivial. Lucien Vogel was dismissed from his post as the editor of *Vu* by its Swiss shareholders, friends of Pierre Laval, who judged its coverage of Spain to be too partisan. Thus Capa could no longer really rely on him. But the days of penury were over and Capa had been able to rent a little studio in the rue Froidevaux that runs beside the Montparnasse cemetery. Now many of the pictures he sold directly carried the credit line: 'Atelier Robert Capa,' which would later add a little more to the confusion over who actually took them . . . Most important of all, the reputation he had built up enabled him to make an agreement with *Time-Life* to go back to Spain, equipped this time with a 16mm Eyemo movie camera to shoot footage for the journalistic film series: *The March of Time*. Neither he nor Gerda had ever used a movie camera but what did that matter: they would learn. They continued working side by side, would certainly make love when they were together. But Gerda had taken a

7. 1936.
Photo: Robert Capa.

further step in her emancipation: she now signed her photographs with her name alone, she dealt directly with *Ce Soir*, *Regards* and the agencies – including the Alliance and the American agency, Black Star.

At the end of May they were together in Valencia, after Capa had left Gerda alone for a time to try and cover the siege of Bilbao. They spent several days on the Nava Cerrada Pass, where the republican army suffered defeat in the offensive that was to serve as a backdrop for *For Whom the Bell Tolls*. During the course of June, passing again through Madrid, which was still besieged and bombarded, they headed further south, where they found the Chapaiev Battalion of the International Brigades under the command of Alfred Kantorowicz (incidentally a remarkable literary historian) whom Gerda had known years before in Paris at the Capoulade or the Mephisto, when both of them used to attend meetings of the Protective Association for German Writers in Exile. Kantorowicz did not recognize her immediately because she was now wearing 'trousers, a beret pulled down over her beautiful red-blond hair and a dainty revolver at her waist.' Among the rare photographs of Gerda out in the field that have come down to us, the best known, which was reproduced in the press after her death, was the one taken by Capa in which, tired, or pretending to be so, she poses, with her face resting on the crook of her arm, squatting beside a boundary stone in the open countryside on which the letters 'P.C.' are inscribed. It is a picture well and truly posed, of which two consecutive shots exist. (It can be likened, in its theatrical style and playfulness to the picture taken by

Capa eight years later, showing Ingrid Bergman seated in an abandoned bathtub amid the ruins of Berlin.) The letters 'P.C.' have been seen, surely rightly so, as a nod and a wink from the two accomplices, who meant them to stand for 'parti communiste'. In fact they stand for 'partido communal', that is to say, 'commune boundary'. It is true that the style of Gerda's costume is somewhat suggestive of battledress, as are her flat shoes, almost espadrilles, and the beret from beneath which a few curls escape in the first picture, a detail carefully corrected in the second. There's no sign of a revolver. But this would not stop Alex Kershaw, one of Capa's biographers, who was even more fanciful than Capa himself, from boldly writing: 'She now wore her dainty revolver on her hip day and night.'

Others have given a very different impression of her mode of dress in their recollections, which would later do a great deal later to lend credibility to the notion of Gerda as an incorrigible flirt. She was said to have liked to walk among the soldiers in high heels and elegant dresses, which, she claimed, cheered them up. Kantorowicz himself also writes: 'She confidently believed that her appearance at the front during the fearsome hours of fascist counter-attacks would be like a battle standard for our exhausted men. That the charm that emanated from her, her daring, her involvement, would boost their morale and encourage the slender and wavering lines of the International Brigades to make a fresh effort.' Characterising her attitude as romantic, he observes: 'No one should be in any doubt about the warmth and passionate nature of her feelings.'

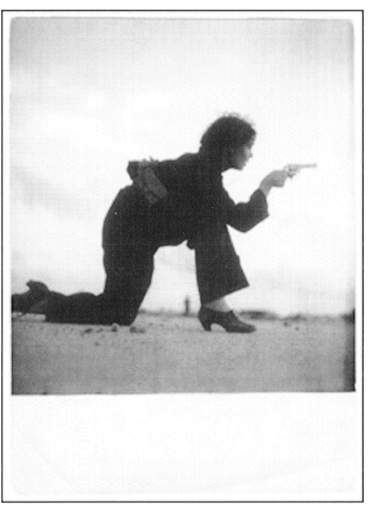

8. Militiawoman training on the beach outside Barcelona,
August 1936.
Photo: Robert Capa.

One photo, however, could reconcile all these differing views. Signed 'Capa', undated, it shows a young woman kneeling, firing a revolver. The young woman's slight figure explains the high but broad heels, her costume is practically the same as in those photographs of Gerda resting against a boundary stone, the profile and the haircut are irresistibly suggestive of her. But all one can do is speculate. A caption in German only states: 'Women's militia in Barcelona: revolver training.' Another, in French, 'Spanish Civil War: fascist militiawoman (Robert Capa-Magnum)'. The aberrant attribution 'fascist,' added at least ten years later (Magnum was created in 1947) is merely symptomatic of the confusion surrounding the Spanish Civil War and the extent to which it was largely forgotten during the years following the Second World War.

High heels or espadrilles, both are possible, after all. But this evidence remains: when one thinks about Gerda's desperate flight across the fields with Ted Allan, as the bombs and bullets rained down, dodging from trench to trench, from foxhole to foxhole, on that day before her death, one can be sure she was not wearing stiletto heels or their contemporary equivalent.

The soldiers appreciated her presence and not just for her fashionable style. During their stay with the Chapaiev Battalion Gerda and Robert learned that the soldiers in a Polish company at an advanced and dangerous location were disappointed that they were not coming to photograph them. 'Nothing could hold her back', wrote Kantorowicz, 'as she tossed her camera onto her shoulder and with profligate foolishness, in broad daylight, ran

across the 180 metres which separated her from them . . . It was the time of the siesta: the fascists seemed to be sleeping. All went well. Gerda filmed at length the position and the comrades of the company. It was almost with force that the men held her and Capa there until dusk.'

The last separation. They would never see one another again. At the end of June Capa left Gerda, and went back to Paris to sell their photographs. Also to prepare for the projected trip to China – probably with Gerda, there is no way of knowing. For her part, assigned by *Ce Soir* to cover the Congress of the International Association of Writers for the Defence of Culture, she remained in Valencia and then followed it, when it moved to wind up in Madrid. She went to the front more and more often. The Congress concluded on July 9th. She telegraphed the paper to inform them that she would remain in Madrid for a few more days. The communist writer Léon Moussinac asked her why. She replied: 'Because of what's happening. The situation is growing more serious every day.' Claud Cockburn saw her returning after dark having walked seven miles carrying her heavy Eyemo movie camera and setting off next day at six o'clock in the morning.

On the afternoon before she died, when the panic stricken republican soldiers were retreating in disorder, raked by machine gun fire from dive bombing aircraft, Gerda could be seen leaping out from her dugout and calling on the retreating soldiers to stop.

We know what followed soon after.

<div align="center">*</div>

But what followed soon after did not end with the funeral vigil in the Winter Garden Palace of the Alianza de Intelectuales Antifascistas Españolas. The news of her death was broadcast throughout the world. Whichever side they were on the papers could not resist this scoop: 'The first woman war correspondent', 'the charming Gerda Taro' had just been killed in action. The American press, incidentally, thought it best to present a virtuous version: 'She died the following morning in the El Escorial hospital, her husband-photographer, Robert Capa, at her side.' In France all the powers of the Front Populaire, with the Communist Party leading the way, prepared to give her a funeral on a grand scale. And so it was.

At *Ce Soir* Louis Aragon at once declared that it was in Paris, the city Gerda had so loved, that her body must be laid to rest: her parents must know that 'their daughter is also, in a way, a daughter of Paris.' And it was to him that the bitter task fell of confirming the news to Capa, who wept, though unable to believe it. His friends who saw him stunned, prostrate on his bed, feared suicide.

The coffin was supposed to be taken to Toulouse. Ruth Cerf took Capa there in the company of Paul Nizan, who was in charge of *Ce Soir's* international pages. But in the end the body arrived at the border post of Port-Bou. Ruth took Capa back to Paris and Nizan went to meet it alone. Meanwhile Gerda's friends paid tribute to 'our little Gerda', 'our unhappy friend'. Claud Cockburn reported that she had died on her feet, facing the gunfire. For Mikhail Koltsov she was an example of 'the millions of women who have risen up against fas-

cism.' For the poet José Bergamín she was 'the huntress of light.'

On July 31st the coffin was met at the Gare d'Austerlitz by a substantial delegation. It was taken to the Maison de la Culture in the rue d'Anjou, where the façade was hung with an immense black veil to mark the occasion. *Ce Soir* and *L'Humanité,* together with the Union of Revolutionary Writers and Artists had organized a kind of ceremonial exhibition in her memory. The communists were making her one of their own, a heroic comrade joining the pantheon of martyrs for the Party, for the working class, and for the International. Then a procession, displaying giant portraits, banners proclaiming that fascism shall not pass, and flags, either red or the tricoloured flag of the Spanish Republic, took her to the Père Lachaise Cemetery where she was interred close to the 'Mur des Fédérés' (the monument to those shot in the Paris Commune). Speeches were delivered, promises were made to continue the struggle until the fascist hydra had been totally exterminated. Following Louis Aragon, Jean-Richard Bloch and José Bergamín, Maria Rebaté spoke on behalf of the World Association of Women against War and Fascism. Gerda's father and brothers came from Belgrade, where they were living in exile. Her father insisted on reciting the Kaddish. Capa could not bear any more. Louis Aragon and Elsa Triolet had to lead him away. It is said that he was fiercely taken to task by the family, who reproached him with having left Gerda alone in Spain.

In a word, as Aragon would write at the end of the

ceremony, 'little Taro' had had 'an extraordinary funeral, where all the flowers in the world had come together.'

In the course of the years that followed streets in communist boroughs would be called 'rue Gerda Taro'. Associations and militant groups would be named after her. Under the German occupation and the Vichy government all that would vanish. But after the war Gerda Taro's name would be honoured in the German Democratic Republic, as that of an irreproachable antifascist activist. In Leipzig a street was named after her and the sign for 'Tarostrasse' carries the legend: 'Young Communist, founder member of the International Brigades, died in Spain in 1937, in the struggle against fascism.'

Ce Soir commissioned Alberto Giacometti to design her tomb. It would have a plain base of even stones, supporting an equally plain stele engraved with the words:

<div align="center">

GERDA TARO

1911–1937

Journalist and reporter

For CE SOIR

KILLED IN JULY 1937

ON THE FRONT AT BRUNETE SPAIN

IN THE EXERCISE OF HER PROFESSION

</div>

Placed on the base are a bowl and a little statue representing Horus, the bird god, symbol of life and resurrection in ancient Egypt. Irme Schaber believes an allusion can be seen in this to a faith in the rebirth of a

world liberated from Nazism. In 1942 the Paris authorities had the stele removed: laconic though it was, the reference to the Spanish Civil War was still an insult to the politics of collaboration. It was later replaced by an inscription showing only her name and the dates of her birth and death. On the second inscription, as on the first, the birth date is incorrect. And neither of them mentioned the existence of a certain Gerta Pohorylle. Today the passage of time has had its effect: the inscription is almost illegible and the bowl has disappeared.

In 1938 Capa, inconsolable, published *Death in the Making, Photographs of Robert Capa and Gerda Taro* in New York. The book is dedicated 'to Gerda Taro who spent one year at the Spanish front, and who stayed on.' As usual, this short cut takes some liberties with the historical truth. Although their two names feature in the title, the book is signed, logically enough by the sole surviving author: Robert Capa. What is a pity is that, since the photographs in it are not credited, no one can guess which were taken by him, which by Gerda. Although there was certainly nothing premeditated in this (quite the reverse: for Capa it was surely a way of perpetuating the memory of the one he still loved), this was the beginning of the fading process. In her book Irme Schaber would later reproduce the backs of two pictures bearing the credit: 'Photo Taro. Black Star.' One has been overstamped: 'Please Credit Robert Capa-Magnum photos Inc.' On the other the credit has simply been crossed out and replaced by: 'Photograph by Robert Capa. © 1965 Magnum photos.'

9. Probably June 1937.
Photo: Robert Capa

THREE

The Camera Eye

'In a war,' Robert Capa is once said to have remarked to Martha Gellhorn, 'you must hate somebody or love somebody; you must have a position, or you cannot stand what goes on.' It is clear that from the start both he and Gerda, Gerda even more so, took up positions unequivocally in the Spanish Civil War. But it is also clear that it was because she could not stand 'what was going on' that Gerda met her death. Because she was determined to refuse defeat, because of her stubbornly desperate longing for victory and, her desire, as camera eye, to take pictures of that victory. Even to the extent of those last shouts of hers at the routed republican soldiers, urging them to return to the fight. True or false, the tale of the pistol worn at her belt gives a faithful key to the character of this woman who, in the familiar cliché, sought to use her camera as a weapon. A cliché that was tested in action: Ted Allan has told how the aircraft of the Condor Legion

took the flash of reflected light from her Leica for that of a gun. More recently in Iraq there have been instances of American soldiers mistaking a movie camera for a machine gun – and killing the cameraman.

Does this suffice to make Gerda Taro a political militant, 'an active member of communist organizations?' This theme recurs, with variations in all the accounts relating her involvement in Capa's life. And two explanations can be found for this.

The first is the immediate appropriation of her death first by the French Communist Party and subsequently the German. What would remain in people's memories for a time were the solemn funeral, the speeches, the red flags, the comments made in the heat of the moment. The monument raised to the heroes of the Party in Leipzig after the war would bear her name, right next to that of Georgi Dimitrov, beneath this flamboyant inscription: 'I am the Will. I am the Strength. I am the Struggle. Victory. The Future belongs to me.' A singular proclamation, from which the one word that might be expected, 'Freedom', is missing. A singular monument, too, when one knows that most of the communist leaders of the International Brigades who survived were ruthlessly put to death by Stalin during the years that followed the Spanish Civil War, accused of having served the interests of foreign powers, of being 'Hitlero-Trotskyists', and more besides. The irrefutable logic of paranoid delirium: from being agents in foreign countries they became agents of foreign countries. Mikhail Koltsov, who was one of the band of journalists who were inseparable both in the field and in

their passionate debates at the Hotel Florida, did not escape. It was a sinister career path, among thousands of others, that of this brilliant journalist who was the inspiration for Hemingway's character Karpov in *For Whom the Bell Tolls*: 'He had more brains and more inner dignity, and outer insolence and humour than any man he had ever known . . .' In 1936 at Valencia Koltsov had woken Arthur Koestler to announce to him 'on a curiously flat note . . . "Attenzione, Agence Espagne. Tomorrow, in Moscow starts the trial of Piatakov, Radek, Sokolnikov, Muralov and accomplices; we are all expected to report the reactions of the Spanish working class".' Radek had been one of his best friends. Whether this was chilling irony, submission to Party discipline or both at the same time, it did not stop Koltsov, recalled to Moscow in 1938, being arrested by the NKVD on arrival and shot in 1942.

Gerda Taro, on the other hand, had the advantage of presenting an image of revolutionary purity, conveniently established for all time by her death: a kind of Joan of Arc of communism. And it was this completely false image, thus hammered home, that came to superimpose itself on some people's memories. A classic trap for memory and all eye witness statements. With the passing years it can come about that witnesses are no longer telling their own stories but relating in good faith those of others they have heard repeated once too often. Not forgetting those who, in less good faith, relay, both to themselves and others, accounts which suit them better and absolve them of their past sins.

The second explanation relates to the climate of the cold war and the witch hunts which ravaged the United States as well as its satellites after 1945. For, in a drive strangely parallel to Stalin's frenzy, all those who had been closely, or evenly remotely, connected with the International Brigades, or simply the republican cause, were accused by the FBI, and still more by Senator McCarthy's House Committee on Un-American Activities, of being henchmen of communism.

Even Robert Capa, the man whose pictures had immortalized the G.I.s in action from the Normandy Landings to the fall of Berlin, was not spared. From 1947 onwards, after the publication of the account of his visit to the USSR with John Steinbeck, he found himself suspected of having belonged to the Communist Party during the Spanish Civil War. At the height of the cold war, it should be said, Steinbeck and he had taken a delight in choosing as the theme of their journey: 'People are the same everywhere': an unpardonable provocation at a time when the Soviet Union, a proletarian paradise for some, was seen by others as a land of bandits armed to the teeth. Worse still in 1953, the State Department, armed with a hundred page report from the FBI, refused to renew his passport on the grounds that, during his visit to China with Joris Ivens, he had belonged to a revolutionary group, the Hankow 'Last Ditchers' – in other words, staunch supporters of Mao Tse Tung. He was finally only allowed to leave American territory armed with a 'patchwork document' of limited duration. His fame protected him but not everybody held such a trump card. Thus

Maria Eisner, the founder of the Alliance Agency, which had worked with so many communist newspapers around the world: how can one explain her peremptory declaration about her former secretary Gerda Taro, that she was a petite bourgeoise at heart but nevertheless a 'rabid and registered communist.' At the time when she made that allegation she was the secretary and treasurer of the prestigious Magnum Agency that she had just founded with Capa, Chim, Cartier-Bresson, Rodger and Vandivert. No question of leaving herself open to accusations of un-American activities, which her Spanish and anti-fascist past might have given rise to. One of the classic procedures of denial is to shift the blame onto others. And when those others are dead, no one is hurt. So, yes, there was a communist at the Alliance Agency but, no, it was not her, Maria Eisner, it was, let's see, that Gerda Taro. It is also true that Pierre Gassman, whom we saw back in the thirties developing photographs in his bidet, and who had become the founder of Pictorial Service, printing pictures for the top names, Man Ray, Cartier-Bresson, Capa, would now affirm that he had seen Gerda Taro at communist meetings . . . but it was all a bit hazy.

Not that there was nothing political about Gerda: to claim that would be absurd. On the contrary everything about her was political. Her life, her behaviour, her photographs. Political in the broadest and truest sense: concerned about her own time. Committed to leading an active life and not just a passive one. To playing a part in History, a part in her own history.

If Gerda had to be defined by a single word it would be the one that is so cruelly missing from the monument in Leipzig: freedom. A word that ipso facto excludes submission to all party discipline. Because her life was just that: freedom as a woman, physical freedom, freedom of spirit.

Freedom as a woman in a world of men. In Germany she took the same risks as her brothers and her male friends. But, for all that, she did not play at being 'a man' – and in this she differed from the stereotype of militant feminists of the period: she knew how to be a man's equal and how to be different. She manipulated the Gestapo underling in the prison in Leipzig who could not bear to see a woman crying. She exploited her seductive charm in her work with Maria Eisner's clients. She liked to be fêted wherever she went, courted, loved, whether among intellectuals or soldiers at the front. But at the Alliance Agency she was no mere little secretary, she was a key part of the operation. In learning photography she was learning a profession that was still almost exclusively male. As is shown by the comments after her death: 'the first woman war correspondent.' She liked to be accompanied by men, they were, after all, very handy in carrying that cumbersome Eyemo movie camera for her – even though it was never much use to her. (Ted Allan claimed that at least it was useful in warding off bullets . . .) She also liked to be photographed; she played to the camera, adopting the most feminine of poses. Nevertheless, just

like many men – notably Capa – who are not content to be one woman's man, she refused to be one man's woman. She encountered a number of men who could respect this choice and respect her for herself. Thus it was with Pieter Bote, who continued to help her, with Willi Chardack, with Georg Kuritzkes, who wrote, when she met Capa, that their lives would not diverge but would continue in parallel. Strangely, it was Capa who was the most bruised by this, as if caught in his own snare. This man whom women flocked to, this man who could not spend a night without a woman, the way he could not spend an evening without whisky, even if it meant going off with a prostitute from the last bar of the night, this man would proclaim until his dying day that she was the woman of his life.

Physical freedom. That of the *Naturfreunde* who bathed naked in the icy waters of the lakes. That freedom which refuses to confuse passionate love with physical love. She had the wherewithal to shock macho men like Hemingway, who only saw women as Dorothy Bridges, a 'second sex' with the brains of sparrows, apart, of course, from a few admirable exceptions: the mother (who is always a saint), the '*pasionaria*' or heroic female warrior, personified by Ingrid Bergman in *For Whom the Bell Tolls*. Ted Allan, the handsome political commissar, seems to have been another who was shocked. He was, he says, passionately in love with Gerda. Back in his native Canada he became a respectable citizen but remained politically committed, a writer, the author of plays and film scenarios, notably with John Cassavetes. In 1939 he

wrote a book in which he fictionalised his Spanish experience, *The Time of a Better Earth*. In old age he confided his memories to his son. How does he describe his first meeting with Gerda in the bar at the Florida Hotel, where he was with Dr Norman Bethune, his boss? 'Met Robert Capa and his girlfriend, Gerda Taro. Yum! Yum! Beth and I giggled. 'Isn't she beautiful?' I said. 'A delicious thoracic creation,' he said. 'Yum, yum', I said. 'Make that ditto,' he said.'

In July, when Capa had to go back to Paris, he entrusted Gerda to Ted, who repressed his feelings (so elegantly alluded to) and discharged his mission by accompanying her on visits to the front. One evening when he was sitting on a chair in Gerda's room, while she went into the bathroom – a purely chance presence, he explains, he had simply come to show her some short stories he had written – he found himself torn between love and duty like a character in Corneille. She emerged.

I tried not to look at her bra or panties. She lay down on the bed. I sat in my chair.

'Do you feel like taking a nap before we go to dinner?' she asked.

I moved to the bed, removed my shoes, and lay beside her, making sure our bodies did not touch. I lay there stiffly and watched the ceiling. She turned and touched my right eyelid with her fingertip. 'A man shouldn't have such eyes'.

I thought she meant I had woman's eyes.

She touched my cheek, then lay back and burst

out, 'I'm not going to fall in love again! It's too painful.' She sounded irritated.

'What do you mean?'

'I loved someone. A boy in Prague. Killed by the Nazis. It's too painful.' She took a deep breath.

'But don't you love Capa?' I asked, puzzled. 'I do love Capa, but not the way I loved Georg. Capa is my friend, my copain.' She looked at the ceiling. I studied her small nose and perfect mouth, her golden-red hair. Our bodies still were not touching. I moved away from her quickly when my hip touched hers. I tried not to move, or make a sound. I hadn't understood what she was saying. I didn't understand anything that afternoon. We lay like that for many long seconds. Then she placed her hand on my stomach, looked at me with a serious expression and moved her hand to my thigh, near my groin.

'Do you like being touched here?'

I nodded quickly, twice: I held my breath. She took my hand and placed it in her groin. 'I like to be touched there too!'

I caressed her there gently, carefully, hardly moving. Then I withdrew my hand and stared at the ceiling again.

We lay there, neither of us moving. 'She's Capa's girl,' I thought. 'He placed her in my charge.' We had been dear friends for a month now, she and I. I wondered if it might be all right to turn and gently kiss her on the cheek, like a friend, but I didn't dare.

She turned on her side and studied me: 'You're

incredible,' she said. She sat up. 'I'd better dress.'

She looked at me, touched my cheek, bent down and kissed my forehead smiling a smile I did not understand. She kept glancing at me.

Why is she looking so sad? I asked myself.

She got out of bed and started dressing. I lay still on the bed, numb.

She finished dressing. I put on my shoes and sat there. 'Are you going to marry Capa?'

She shook her head: 'I told you, he's my copain, not my lover. He still wants us to marry, but I don't want to.'

I sat on the edge of the bed, unable to move. She stood in front of me. I felt like crying and smiled to hide it. She touched my head. I said: 'He acts like you are lovers. He put you in my charge. He asked me to take care of you.'

She sighed. 'Yes. He was clever. He saw how I looked at you.'

I heard myself saying: 'My mother will love you.'

'I don't want to live in Montreal', she answered. 'We'll live in New York.' We said no more but went to dinner.

I think I was in shock.

'In shock,' or, more conventionally, 'shocked'? Reading such an account – if it is accurate, for we only have the man's side of the story – it is hard to make up one's mind. It is no longer a matter of 'Yum! Yum!' The male banter is at an end. Let us remember that this is an account given

by a father to his son. A lesson both in puritan morality and communist morality (a pleonasm)? A true model father. Perhaps, more simply, it is the unease, the panic of a still naïve young man, scarcely out of his adolescence, confronted by a woman six years older than him and discovering an unknown world. Perhaps one may also give a thought to Gerda 'looking so sad', who was to die two or three days later without having experienced the moment that she quite simply wanted. The thing one can read in it that makes most sense is Ted Allan's admission that he understood absolutely nothing. And this was not the end of it. When he returned to Paris shortly afterwards, hobbling on crutches, the first person to visit him at his hotel was Robert Capa. 'But can't you see that I was in love with her,' the young man remarked, taking offence. 'So what?' replied Capa. 'No one could resist her.' And they became inseparable. Bob wept on Ted's shoulder, stayed with him, looked after him. They planned to write a book together. And when, with the same touching impulse, they both decided to go and see their mothers, Capa in New York, Allan in Toronto, they set sail on the same boat.

Freedom of spirit. In Leipzig Gerda's involvement in the resistance to the Nazis, however substantial it was, seems totally logical: she was Jewish, she was among the executioners' first chosen victims. Yet she could have thought, as others did, that by resigning herself to the laws of the new masters she could gain time and avoid the worst. (Her parents would not decide to emigrate until months later.) Or else that if she left immediately she would be able to wait somewhere peaceful for the Nazi

madness to pass, since at that time many people thought it could not last. After all, she had already spent a year in Geneva. But her instant rebellion was of a different nature, too. What were those the clandestine unions' leaflets that she distributed protesting against? Against the banning of the unions and their replacement by a single organization that bore the name: *Kraft durch Freude*, 'strength through joy'. For her, two irreconcilable words. Her arrival at the Nazi prison dressed for going out dancing already constituted a political manifesto in itself, more eloquent, perhaps, than the contents of the leaflets. It was to proclaim to the world that she would not let herself be constrained by a society in which, in a monstrous coupling, joy was to be in thrall to strength.

*

If one had the soul of a detective one could evidently seek to discover what organizations or parties Gerda may have belonged to during her years in Paris. One might learn something, no doubt, from the reports of the Renseignements Généraux (the French Special Branch), or the files of the Sûreté (the French CID). Even though in dossiers of this kind the proven facts are often polluted by tittle tattle, chiefly designed to win credit for the informers and to justify their pay cheques.

But if we stick with what is known, she frequented anti-fascist circles and, apart from the vague 'communist meetings' referred to by Pierre Gassmann, the places where she could be seen, above all, were cafés. The story

of her encounter with Capa begins at the Café du Dôme. Not at a political meeting. Richard Whelan believes that she belonged to the SAPD, the Sozialistisische Arbeiterpartei Deutschlands, the Socialist Workers Party of Germany, 'Liberal, socialist, and anti-Soviet.' This makes some sense, but he gives no proof. What can be firmly stated, however, is that on their early visits to Spain, when Gerda and Capa arrived in Barcelona, they were not to be seen immediately linking up with communist organizations, which would have been natural if she had had links with comrades in the French and German parties. The people they photographed and with whom they fraternized were essentially the anarchist militias, from the FAI, the Iberian Anarchist Federation and the CNT, the National Confederation of Labour, and the Trotskyists of POUM (Partido Obrero de Unificacion Marxista). How could Gerda have failed to earn a severe reprimand, if not worse, had she belonged to a communist organization that had seen her returning to Paris with pictures which glorified the anarcho-syndicalists of the Union of Proletarian Brothers? And would she not have bawled out Capa for focusing on these people?

From the start of the war, narrow sectarianism among the communists was sufficiently strong for a paper like *Regards*, (though it claimed to represent a broader point of view than that of the Party on which it was dependent), not to have retained such photographs among those supplied to it. It did not publish the picture of the militiaman shot down until a year later when, having been reproduced everywhere, it had become a symbol of the

republican cause. It would then appear in the body of an editorial by André Wurmser stigmatizing non-intervention, with no caption and with the text superimposed over almost all of the background. A man's death had now simply become a graphic motif.

Mikhail Koltsov, who arrived in Barcelona at the same time as them, was not given to mincing his words when writing about the non-communist far left. In his articles for *Pravda*, which were often reprinted in *Ce Soir*, *L'Humanité* and *Regards*, and also in his *Spanish Diary*, a good third of what he wrote was devoted to portraying the anarchists as saboteurs of the revolution, troublemakers, incompetent and cowardly at the front. As for the militants of POUM, they were agents financed from abroad. For him, an orthodox communist, they were enemies just as deadly as the fascists confronting them.

When Gerda attended the Congress of the International Writers Association for the Defence of Culture in July 1937 she can be seen as more concerned with the situation of the fighters than with internal debates. But behind the façade of harmonious unity 'in the defence of the Republic' these were violent. The communists had a very specific watchword: the Congress must be led to denounce all traitors who called into question the exemplary value of the Soviet Union as the fatherland of socialism, a model of the Revolution and a paradise for the proletariat. One name came up again and again, like an obsession: that of André Gide. He had just published his *Retour d'URSS* ('Return from the USSR') and the reservations and criticisms he expressed in this

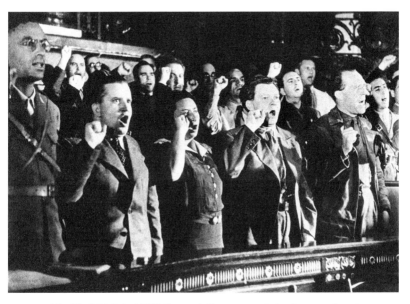

10. Madrid, July 1937. Second Congress of the International
Association of Writers for the Defence of Culture.
Photo: Gerda Taro.

were to be condemned. The old guard was mobilized: Romain Rolland, Henri Barbusse. And thunderous declarations were obtained from the Catholic poet José Bergamín, which rounded off the final session: 'I speak on behalf of the whole Spanish delegation. And also on behalf of the delegation from South America. Here in Madrid I have just read that new book by André Gide about the USSR. In itself, the book is insignificant. But for us the fact that it has appeared at this time, when the fascists have Madrid in their sights, lends it a tragic significance. We are all supporters of freedom of thought and criticism. That is what we struggle for. But André Gide's book cannot be described as a book of free and honest criticism. It is an unjust and unworthy attack on the Soviet Union and Soviet writers. It is not criticism, it is calumny. What has emerged from these last few days has been beyond price: the solidarity of individuals, the solidarity of the people. Two peoples find themselves united in these harshly testing times, the Russian people and the Spanish people. Let us pass over the unworthy conduct of the author of this book in silence. Let the deep and contemptuous silence of Madrid travel all the way to André Gide, and let it be a vital lesson to him!'

Tumultuous applause.

Reading this speech today produces a nightmare feeling. Was it to give birth to this that the Congress had rallied the greatest progressive writers in the world? Was this an effective response to the daily more imminent demise of the Republic, to the intervention of the fascists? Was condemning a book published in Paris which

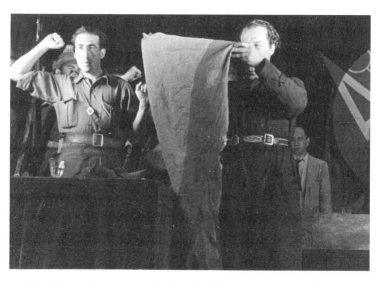

11. Enemy flag captured in Battle of Brunete presented at the Second Congress of the International Association of Writers for the Defence of Culture.
Photo: Gerda Taro.

12. February, 1937. On board the republican battleship *Jaime I*.
Photo: Gerda Taro.

criticized a regime a thousand miles distant from the Spanish tragedy – even if one fervently believed this regime was a workers' paradise – was this the way to save Madrid from Franco's bombardment, Spain from dictatorship and the world from a new world war?

*

It is impossible to know whether Gerda was present for this closing speech, or if she took part in the applause and ovation. She might have been at the front that day. Be that as it may, it is, by definition, impossible to applaud when holding a camera in one's hand. And shouting 'bravo!' with your eye glued to the viewfinder is not advisable if you want to take a good picture.

But I have no reason, either, to suppose that Gerda did not go along with the general line taken by the Congress. Her photographs do indeed show writers and artists galvanized, united in support of the common cause. In some they are all recognizable, thus there is one where the following can be seen lined up like a string of onions: José Bergamín, Claude Aveline, André Malraux, Stephen Spender, Tristan Tzara, Anna Seghers, M.A.Nexö, Mikhail Koltsov, Malcolm Cowley, Alexis Tolstoi. If I cite that litany of names in full (as identified by Irme Schaber), it is because they were all at the time unreserved supporters of the Soviet Union. They are gathered round the Spanish Foreign Secretary, Julio Alvarez del Vayo, who was one as well. Another photograph shows a gang of individuals, with raised fists, singing an apparently uplift-

ing anthem at full throttle: impossible to put names to their faces, but they strike me as looking more like party apparatchiks doing their duty than intellectuals. Yet the two things are totally compatible. This was the kind of record required of Gerda by a communist press which was, according to the time honoured phrase, 'ready to fight to the last Spaniard.'

In this general line one must take note of what is being talked about. Over the course of the past year improvisation and the mobilisation of all the people's forces had given way to strict organization, increasingly controlled by the communists, the watchword being: win the war at all costs. Faced with the lack of comprehension shown by the great democracies, France and Great Britain, and the consequent lack of support from them, the republican government turned to the Soviet Union. The Prime Minister, the socialist Largo Caballero, was replaced by Juan Negrin, who was closer to the Soviets. The communists took control openly, or sub rosa, of the key responsible posts. First of all, those at the Ministry of the Interior and hence the police; then those at the Foreign Ministry, and thus for external propaganda; and those of the army. The latter was dependent on the Soviet Union for both munitions and officers. As were the International Brigades, even more so, of course, being for the most part made up of communists and led by men who had the confidence of the Comintern when they were not directly appointed by it.

On their first visit, when they arrived in Barcelona in August 1936, Bob and Gerda had to improvise. Their

subsequent trips, on the other hand, took place, logically enough, under the aegis of the republican government. Thus they were developing their photographs in the propaganda department's laboratories. No more pictures of anarchist militiamen and others: their photojournalism was now done with the regular army and the Brigades, all the more so because in the latter they often ran across old friends. In a word, they were now 'embedded' reporters.

At the beginning of 1937 the communist hold on the machinery of the state resulted in increasingly harsh pressure on the anarchists and POUM: their militias were disbanded or incorporated into the regular army, their officers arrested. In Barcelona in May 1937 this repression led to bloody battles in the course of which the revolutionary parties were wiped out. The leader of POUM, Andrés Nín, was arrested and assassinated on the orders of the Comintern: it was not only on Franco's side that war had been declared on intelligence. In his essay 'Looking Back on the Spanish War' George Orwell, who had enlisted in the POUM militia, would speak of 'the struggle for power between the Comintern and the Spanish left-wing parties and the efforts of the Russian Government to prevent revolution in Spain.' Let us note, however, that before leaving the country in 1937 he nevertheless wrote that he really believed in socialism, which had never been the case before. A socialism that had just been crushed on Stalin's orders.

In March 1937, when Bob and Gerda encountered Hemingway, Martha Gellhorn, John Dos Passos, Mikhail Koltsov and Joris Ivens at the Hotel Florida, was there

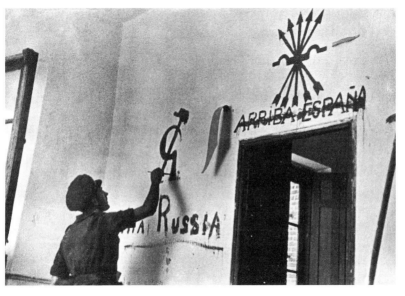

13. Brunete, July 1937.
Photo: Gerda Taro.

really nothing more taking place in those evenings together but merry and genial debates? Hemingway and Dos Passos had joined forces to take part in the same project: that of the major documentary film by Joris Ivens that would be *The Spanish Earth*. A film supported and financed by the republic's propaganda services, that is to say, behind them, by the Soviets. Koltsov's role in this was to some extent that of political commissar while the American writers were the essential moral guarantee. Very quickly a conflict arose between Hemingway and Dos Passos. Both had known Spain for a long time, both were resolutely committed to the anti-fascist camp. Nevertheless, beyond the cult of great bullfighters and Iberian virility, it was Dos Passos who was the more deeply steeped in Spanish culture: his early writings bear witness to this, the account of his travels between 1916 and 1920, *Rosinante to the Road Again,* in which he rubbed shoulders familiarly with the classics of Spain's Golden Age, Miguel de Cervantes, Jorge Manrique, Raymond Llull, as well as those of his own time, Antonio Machado and Joan Maragall, whose poetry he had translated.

And of these two it was also Dos Passos who was the more politically aware: he had links with the great Soviet creators, Meyerhold, Eisenstein, Pudovkin. And he himself, in his conception of literature, in both the sense and the form of his writings, was a political and authentically revolutionary creator. And it is from him that the discord came. Hemingway, for a long time still, went along with the general line of the republican government. He would

defend it in his play, *The Fifth Column*, which exalts the relentless hunting down of 'enemies of the people.' But what precisely does this form of words refer to? When he arrived, Dos Passos learned of the death of his best Spanish friend, José Robles: he knew that Robles was totally committed to the republican cause from the start and had played a vital role in the defence of Madrid at a time when all seemed lost. But there was no doubt: designated, like Andrés Nín, as an enemy of the people, and a member of the fifth column, this free spirit, too free, had been abducted and executed by the political police. At this period of time W.H.Auden would write his celebrated poem, 'Spain' in which these lines appear:

Tomorrow the bicycle races
Through the suburbs on summer evenings. But
 today the struggle.
Today the deliberate increase in the chances of
 death,
The conscious acceptance of guilt in the necessary
 murder.

He would later repudiate that 'necessary murder'. Meanwhile it was certainly around this question that the confrontations between Hemingway and Dos Passos revolved, which led to a violent breach and to Dos Passos's cry: 'Farewell, Europe!' It is not conceivable that Capa and Gerda were not witnesses to this.

Did they remain neutral? Were their minds elsewhere? Their minds only on pictures and on nothing but pictures?

Among the photographs Gerda took of the capture of Brunete, there figures – apparently without this causing any qualms – one of a republican soldier replacing the nationalist slogan: *Arriba España* with *Viva Russia*.

*

Gerda aspired to a different world. Different to the one that had driven her from Germany: the Nazi world. Different to the one she knew in Paris: increasing xenophobia, agitation by the anti-republican 'Leagues' (including Action Française), which led to anti-government riots outside the Chamber of Deputies on February 6 1934 after the death of the racketeer Stavitsky, for which the government was blamed; an intolerable contrast between flaunted wealth and poverty, luxury cars and public soup kitchens. Grinding penury had been the daily lot of her and her friends: then suddenly, like an immense surge of hope, the Front Populaire had come. Very different from that society of the strongest which Franco desired to impose on Spain.

In this she was like all those who sought at that time to participate in the dream of a 'better world' rather than merely looking after number one. For such people there was then a great light in the East. When, in 1935, Gerda frequented anti-nazi circles, when, in 1936, she was fired with enthusiasm for the cause of republican Spain, 'such people', among thousands, included André Gide, who, like Panaït Istrati or Nikos Kazantzaki before him, had not yet set off for the USSR full of enthusiasm and returned

disenchanted; André Malraux who fought both in Spain and the French Resistance and whose political alliance with De Gaulle only came in 1945; Arthur Koestler, who was quite simply a Comintern agent; Paul Nizan, whose break with communism in 1939 led to his vilification after the war, though he was later championed by Sartre. 'Such people' includes all the writers who fought in the International Brigades as well as the journalists and writers, who had come, like her, to Spain: Gustav Regler, Hemingway, Dos Passos, W.H.Auden, and who, some later than others, would become disenchanted with the radiant future. But we are not there yet. For the moment they clung to this inspiring vision of a different world, not just so as to side with the workers at the Renault factory in Billancourt, but in order to bring real hope to them.

Finally, if we have to put a finger on an unflinching form of political commitment in Gerda, it is to be found where serious people would least expect to find it. We have understood nothing if we disregard her taste for gambling, the very thing that makes her impossible to dissociate from Capa. Gambling, not as a pastime, a mere attitude, but as a form of resistance, a political weapon. A means of survival essential in confronting the nazi terror, as well as in confronting the constraints of a hostile society. In this they may be compared with another artist, the master of photomontage, an émigré, like them, who was waging a singular campaign against nazism at the same time in Prague: John Heartfield. He was not the inventor of the symbol of the raised fist but he was one of the first to have used it systematically as a graphic motif.

Commenting on his work, 'Livestock immunized against crisis', Denis Roche gives a wry definition of it: 'The German Heartfield against the Nazi Hitler: H against H. By taking a pair of scissors, and cutting out photographs here, there and everywhere . . . never deviating, Heartfield would construct one of the most incisive works in the history of art. It goes beyond humour, beyond satire, too: it is a relentless war against the garbage and darkness that threatens.' But wasn't this just what Gerda and Capa were doing as they travelled 'here, there and everywhere' (an 'everywhere' tragically cut short in Gerda's case) with their cameras and their uncompromising freedom?

*

When one examines who Gerda and Capa worked with in France during the two brief years of their collaboration four key reference points recur: the magazines *Vu* and *Regards;* the newspaper *Ce Soir* and the Alliance Agency. It all really began with *Vu*. Not just the career of André Friedmann, who so rapidly became Capa, but the whole history of modern photojournalism. The editor, Lucien Vogel was an exceptional individual. A high born bourgeois, even an aristocrat, this press baron deserves better than the brief description Cartier-Bresson gave of him: 'He was tall and wore a checked suit. Full stop.' Lucien Vogel might have remained content with his classy and lucrative business empire: *Le Jardin des Modes* (in his days of penury André Friedmann, posed for a sketch in it), *Femina, La Gazette du bon ton.* But this man of

eclectic tastes, who also painted and drew, liked finely produced books and published Max Jacob and André Gide. And, crucially, he was the first person in France, and probably in the world, to have understood the veritable revolution introduced into the press and the profession of reporter by the invention of cameras that were light and easy to use: basically the Rolleiflex and the Leica. The twin-lens system of the Rolleiflex and the accurate viewfinder of the Leica enabled the photographer to frame the picture with accuracy. The speed of the cameras and modern film allowed fast exposures, which removed the need for a tripod. With the Leica, the first camera with the 35mm format, it became possible to shoot thirty-six pictures one after the other without changing films. With both cameras shots of a five hundredth and soon a thousandth of a second were possible. This, together with the appearance on the market of new 'Belinograph' fax machines, weighing – and this too was a revolution – less than twenty kilograms, paved the way for almost immediate transmission. The scale of this revolution needs to be noted. For some time now wireless telegraphy had enabled the living voices of the world to intrude into people's homes. Photojournalism caused the living faces of the world to enter there too. Thus from a technical revolution was born an innovative press: without the people who used these new cameras this press could not have existed; and without this new press an equally innovative profession, that of photojournalism, would not have seen the light of day.

Thus in 1928 Lucien Vogel created *Vu,* the first issue

of which contains sixty photographs. Gone are the posed and frozen scenes, all the conventions imposed by the ponderousness of the cameras, as they traditionally used to appear in the illustrated weekly *L'Illustration* (founded in 1843). For the first time in large circulation newspapers and magazines the world revealed itself freely to the reader's eye. In the editorial for this first issue Lucien Vogel set out his plan: 'Conceived in a new spirit and realised by new methods, *Vu* brings a new formula to France: world news with illustrative reportage . . . From wherever significant events are taking place, photographs, despatches and articles will come to *Vu,* which will thus put the public in touch with the whole world and make universal life accessible to the eye.' Henry Luce, the founder of *Life,* has written: 'Without *Vu, Life* would not have existed.'

In 1933 this large circulation magazine published the first reports on the Nazi concentration camps. After this, who can say that it was not up to the minute? Lucien Vogel – whom Kertész nicknamed 'le Patron-Camarade' ('Comrade Boss') – certainly had his heart on the left. He was the brother-in-law of Jean de Brunhoff, the immortal creator of Babar the elephant, and published the first Babar books. If one recalls the illustrations to *Babar the King* it can be seen that back in the nineteen thirties these evoked an image of the ideal city: Célesteville, the elephants' city, is harmoniously laid out beside the river, dominated by the Palace of Pleasure and the Palace of Work. The grand parade of the elephants, grouped according to their craft guilds and carrying banners,

celebrates workers' solidarity, prefiguring the parades of the Front Populaire. Lucien Vogel was also the father of Marie-Claude Vaillant-Couturier, the wife of Paul, the Communist Party leader. This did not make a militant of this staunch capitalist, merely a 'travelling companion.' But it would be enough in 1937 for those more capitalist than him to oust him from *Vu*.

Regards, on the other hand, was a creation of the Communist Party, destined, among others, to compete with *Vu* for its readership. It was not simply aimed at militants or Communist Party sympathizers, but at readers who would form the great surge of electoral support for the Front Populaire. It made a first and short lived appearance in 1920 with the title *Regards sur le Monde du Travail* ('Views of the world of work') and reappeared in 1933, keeping only the first word of its original title. It really took off in 1934 when it became a weekly. Although it was a rival to *Vu* in its form and the concept of news in pictures, it took its inspiration from the German *Arbeiter Illustrierter Zeitung,* ('Workers' Illustrated Newspaper') which, itself, was the heir to *Sowjet-Russia im Bild* ('Soviet Russia in Pictures') launched in 1921, in which the greatest Soviet artists collaborated and which published photographs and photomontages by the Russian constructivists.

The prime graphic concept of *Regards* plays on juxtaposition, cutting, montage, the effect of a mass of illustrations, not hesitating to crop and reframe. From the start the weekly, edited by Georges Sadoul, subsequently overseen by Léon Moussinac, advertised that its editorial

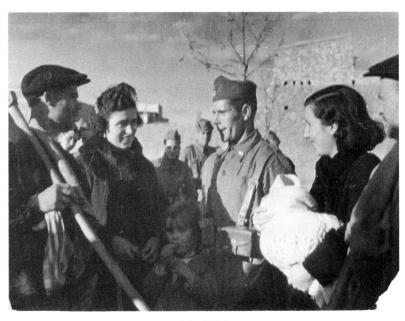

14. 1937.
Photo: Gerda Taro.

committee contained some prestigious names alongside committed communists, French (Henri Barbusse and Vladimir Pozner) or foreign (Maxim Gorky and Isaac Babel); these included André Gide, Romain Rolland, Charles Vildrac, André Malraux, Eugène Dabit. The painter Édouard Pignon would be responsible for its graphic design.

With the advent of the Front Populaire the range of contributors would be further extended. These included the militant theatre group, Octobre, with whom Jacques Prévert made his name. The founding idea links up with the one formulated by Walter Benjamin in his essay 'The Work of Art in the Age of Mechanical Reproduction': 'Mass reproduction brings about the reproduction of the masses.' The ideology which makes illustration a fundamental element in information is that of a 'new aspect of mass art', as it was expressed by the great photographer and Soviet theorist of photography, Alexander Rodchenko: 'In photography there are old viewpoints, those of the man standing up and looking about him. What I call "umbilical photography", with his camera on his stomach. The modern city . . . has brought a change in the psychology of visual perception. The interesting angles of vision for the current age are those from down below looking up and from above looking down, and that is what we must work on.'

In *Regards*, side by side with photojournalism by Cartier-Bresson, Chim or Capa, the notion of 'poetic realism' was taking shape (the demarcation line is hazy). This is close to the films of Marcel Carné and here one

encounters Brassai, Gisèle Freund, Kertész, Denise Bellon. Everything should tend to create a lyrical image of what must be a great human brotherhood, the universality of workers opposed to the alienation of world capitalism and all conceptions of a 'master race'. The great success of *Regards* seems to have been to take upon itself this affirmation 'Only one truth exists, the brutal truth of photographic documents.' This, at a time when a certain innocence prevailed on the part of readers confronted with photographic documentation, which was considered to be the irrefutable proof of reality and of one single reality. As if only one viewpoint were possible: the viewpoint of *Regards*.

Edited by Louis Aragon, *Ce Soir* was launched in March 1937. For the Communist Party the idea was to repeat, with a daily, the successful experiment made with the weekly, *Regards*: to attract, in both the editorial team as well as the readership, the broadest possible spectrum of the left, in competition with the so-called 'bourgeois' press, with *Paris Soir* at its head.

We find ourselves here at the heart of a fierce battle: the battle of pictures. It is certainly not new. From the late nineteenth century the importance of photographic documentation had been understood and used. But for a long time it was only a substitute for engraving. For a long time, too, it was only there to illustrate a text. There are photographs of the Siege of Sebastopol, the American Civil War, the Paris Commune, the Great War. Bearing in mind among other things, the cumbersome nature of the cameras and the length of the exposure time, these are

meticulously set up. Many of them are only reconstructions, most of them carefully retouched. But early on they were used to support a very specific case. Thus with photographs of the Commune: on pictures of the barricades, taken before the battle, one can see men adopting postures intended to glorify the heroism of the communards: those, from the other side, devised to portray the execution of Monsignor Darbois, the Archbishop of Paris, and the hostages of the Commune, for which models were posed, are nothing other than academic paintings, seeking to stigmatise the cruelty of the same communards.

Hence the enthusiasm that welcomed the authentic snapshot. Surely a 'snatched' picture (taken *'à la sauvette'*) – a formula which, though invented by Cartier-Bresson, went much further than his own work – ought not to be able to lie any more. All at once photographs acquire the same value as news stories, with the advantage of immediate impact: one glance and the shock effect is guaranteed. Instant snapshot, instant message: straight from the photographer to the reader. All at once, too, the photographer, who up to that time was often anonymous, became a reporter in his own right. Pictures were credited and the profession was recognized as it had never been before.

From this illusion, that a true photograph inevitably gives a true picture of the facts, was born the idea, as simple as a hammer blow, that whoever controls pictures will control those who look at them. As Walter Benjamin saw very well, by appropriating this mass medium, those in power will take over the masses. He who commands

the mastery of images will be master of the world. With the October Revolution agit-prop appeared. Agitation and propaganda. Hitler would treat Leni Riefenstahl as a star. The word 'propaganda' came to be widely used, as in Goebbels's 'Propagandastaffel' ('propaganda squad') and did not immediately have a negative connotation. Even in the frail Third Republic of France the subtle Jean Giraudoux, after his appointment as High Commissioner for Information in 1939, would use the word freely. Expounding such a thesis today is pushing at an open door: in this all-televisual age everyone, including saloon bar wiseacres, recognizes the manipulative power of the image. This was not yet the case during the thirties.

One cannot use agit-prop as an essential instrument in the conquest of the masses without giving it a 'base', designed as the one centre of control. And it is not lapsing into a spy novelist's interpretation of History to point out that such a central base existed in Paris throughout the nineteen thirties. It had a name, that of one man: Willi Münzenberg. He was an agent of the Comintern sent to Paris by the Kremlin in 1932 and charged with implementing the new 'common front' policy decided on by Stalin. There was no event, no demonstration, no new newspaper or magazine, no new film, no intellectual trip into the broad spectrum of anti-fascism that was not due to his initiative. International Workers' Aid; the Amsterdam Congress and the Pleyel Meeting (the Committee for Peace against Fascism), where all the intelligentsia of the left shone, Gide, Malraux, Aragon; the Union of Revolutionary Writers and Artists, the Protective

Association for German Writers in Exile; the World Association of Women Against War and Fascism, and dozens of other unitary organizations, he was the prime mover of them all. There was not an anti-fascist newspaper – *Ce Soir* – or magazine – *Regards* – or periodical – *Europe, Vendredi* – or publishing house – Editions du Carrefour – behind which his shadow cannot be sensed, whether as its initiator, or as someone who could support it or bring in funds. He was a friend of Lucien Vogel, who found lodgings for him on his arrival in Paris, and it is reasonable to speculate over whether it was not he who enabled Maria Eisner, already a militant anti-fascist in Berlin, to relaunch the bankrupt Agence Anglo-Continentale as the Alliance Agency. Alluding to his tireless and omnipresent activities, some people have spoken of the 'Münzenberg Trust': it might be more appropriate to refer to a 'galaxy' or a 'nebula'.

Willi Münzenberg, a proletarian from Thuringia, a communist from the word go, a member of the Spartacus League, was the undisputed master of agit-prop. In the days of the Weimar Republic it was he who created the formula for the *Arbeiter Illustrierte Zeitung*, which would serve as a model for *Regards*. At that time his 'Trust' controlled the people's soup kitchens, through the International Workers' Alliance, as well as the launch of Pudovkin's film *Storm over Asia* and the co-production of Eisenstein's films. It was he who, when in exile, and by means of publications such as the 'Brown books' on the Nazi Terror, mounted the campaign which transformed the trial of Georgi Dimitrov and the other communists

accused of setting fire to the Reichstag into a humiliating defeat for the Nazis.

Arthur Koestler was his subordinate for several years, alongside his faithful and devoted right hand man, Otto Katz: it was on his orders that Koestler infiltrated the heart of fascist Spain under the cover of a liberal English newspaper, the *News Chronicle*, and it was thanks to Münzenberg that an international campaign freed him from one of Franco's gaols, where he was under sentence of death. Of the man he characterised as 'the grey eminence and invisible organizer of the anti-Fascist World Crusade' he has left this passionately admiring portrait: 'Münzenberg was the original inventor of a new type of communist organization, the camouflaged front; and the discoverer of a new type of ally: the liberal sympathizer, the progressive fellow traveller . . .' 'Undisturbed by the stifling controls of the Party bureaucracy, the Münzenberg Trust's newspapers, periodicals, film and stage productions were able to exploit imaginative methods of propaganda in striking contrast to the sectarian, pedantic language of the official Party press.'

Willi Münzenberg's last creation, in 1938, was a review aimed at rallying the opposition to the Nazis still more broadly, *Zukunft* ('Future'). Capa contributed to it immediately. But already a new 180 degree turnabout was on its way from the Kremlin: the Soviet-German Non-aggression Pact. *Zukunft* was now out of line. So was Münzenberg. Interned by the French government in 1939, in 1940 he was found mysteriously dead beside the road that would have taken him into Switzerland. As if to add

insult to injury, the celebrated columnist of *L'Oeuvre* (a left wing periodical in the 1930s) Geneviève Tabouis, though reputed to be one of the best informed of French journalists, would later write in her book *They Called Me Cassandra*, published in New York in 1942, that everyone in Paris knew Münzenberg was a police spy who had handed over a list of all the anti-fascist Germans. It needs to be said that Geneviève Tabouis's informant on the subject of the secrets of the Kremlin, was none other than Otto Katz, that devoted 'right hand man' who had been installed by the Comintern alongside Münzenberg to spy on him faithfully. He took advantage of this to pass on to the credulous journalist whatever Moscow dictated to him. To such an extent that Tabouis's fellow journalists nicknamed her 'the Kremlin's inkwell.' With the grim justice of History, in 1947 Otto Katz was condemned to death and hanged in Prague as a foreign agent, Titoist etc, following a trial which was later made famous by the book and the film starring Yves Montand, *L'Aveu* ('The Confession').

There is no record of any encounter between Gerda and Münzenberg, although there was certainly no member of the émigré community in Paris who was unknown to him. But one can spot coincidences, like that of Gerda's presence at the preliminary meeting of émigrés to create a German popular front at the Hotel Lutétia in February 1936. This meeting was organized and run by Willi Münzenberg under the presidency of Heinrich Mann. And it is known that Arthur Koestler and his wife Dorothee, who were friends with Münzenberg, used to

meet her at the Capoulade. To this one should add some-
thing that is a little more than a coincidence: the Paris
office of the Spanish News Agency, created by the Spanish
Foreign Affairs Ministry, actively circulated pictures by
Capa and Taro; perfectly natural, except that this agency
was in reality owned by Willi Münzenberg, who had close
ties with the Minister, Julio Alvarez del Vayo, who espe-
cially relied on him – and thus on the infrastructure of the
Comintern – for republican propaganda . . .

It was thanks to Münzenberg that the project for the
film *Spanish Earth* could be set up and carried through. It
was he, again, who arranged Joris Ivens's trip to China to
make another film, a trip in which, as we know, Capa
participated, incidentally giving the filmmaker the slip
whenever he could, in order to be able to take pictures
with total freedom.

All this proves nothing, but the fact remains: if one
took the whodunnit view of history to its logical conclu-
sion one could see a long chain stretching all the way
from the 'centre' managed by Comintern to a whole series
of agents which it used for its own ends. If common sense
prevails one may happily resist this temptation. Otherwise
one would equally have to allow that for a certain period
of their lives, albeit a brief one, a great many worthy
people, for example Gide and Malraux, Chim and
Cartier-Bresson, were neither more nor less than Soviet
secret agents. But this fact remains: it was only an extreme
lightness of being that enabled Gerda, like Capa, to move
around with the autonomy of free electrons in this world
that was woven like a spider's web. Love of life, a passion

for their craft, a taste for and habit of gambling, all this protected them, as others are protected by grace.

Arthur Koestler has referred to 'the two basic elements of the revolutionary creed: attraction by Utopia and rebellion against a sick society'. Gerda's Utopia, broadly shared by Capa, had only one name: photography. The universal language. Photography, 'an autonomous means of being political', wrote Raymond Depardon. It was through it, in it, that Gerda was an essentially political being. And everything else is not so much mere literature as simply a secret policeman's dossier.

*

There was, initially, an important difference between Gerda and Capa. In Capa's case photography was a part of the culture he was raised in from childhood. Taking pictures soon became as natural to him as breathing. Like Cartier-Bresson, when he was little he was already at home with the 'Brownie Box', that box as simple and miraculous as a child's toy – which was indeed given to children. Gerda, on the other hand, came to photography at the age of twenty-four, partly by chance, partly from necessity. The chance was to have known several photographers in exile and then to have met Capa. The necessity was to have needed an accredited profession in order to obtain a correct work permit. When they met he already had years of apprenticeship and experience behind him, acquired alongside recognized professionals, notably Kertész: she knew almost nothing. She learned everything

from him in a few months. He was her only teacher. The pupil must have been gifted, since we experience so much difficulty today in telling the difference between her pictures and those of the master. To say that Gerta Pohorylle would have been nothing without André Friedmann does not detract from her merits: since it is also granted that without the dazzling arrival on the scene of the imaginary Capa, Gerda's idea and the creation of the two of them, André might never have attained to the celebrity of Robert – or only later and with greater difficulty.

Who dares wins. Capa is famously alleged to have said that if your picture is no good you weren't close enough. On this subject there is a curious anecdote, reported by Gustav Regler, which goes back to Capa's second trip to Spain, on his own in Madrid under siege: 'The young man disliked the noise of the shells which soon whistled over us . . . Later he asked leave to change his trousers, saying with humour that it was his first battle and that his bowels had been weaker than his feet.' This was not yet the Capa of the Normandy landings, who, on a beach raked with apocalyptic gunfire, saved the life of a GI on the point of drowning. And the fact that he continued all his life to work with fear in his belly only confirms his courage. But perhaps he would never have got 'close enough' if there had not been that formidable working solidarity, Gerda stimulating Capa and Capa helping Gerda. It is in this, first and foremost, that they are indissociable.

To be 'close enough' plainly means getting to the heart of things, taking all possible risks, being as one with the

camera and thinking only of one thing, the picture to be taken. To be the camera eye. But, as is often the case with throwaway remarks, and particularly Capa's, this one should not be taken too literally. There are not a great many close-up shots in Capa's work nor in Gerda's: they tend mainly to be middle distance shots, in which the subject is naturally placed into the surrounding universe. Denis Roche defines very well what makes the value of this when writing about the last photograph but one taken by Capa: soldiers seen from behind walking in a paddy field: 'His "close enough" was not that of other people: his was at a distance dictated by elegance and respect.'

There is another form of closeness that shines forth in many of their photos taken in Spain: a kind of immediate current of quasi-fraternity, that seems to be passing between them and those whose picture they were 'taking'. But in this case 'take' is not quite the right word, because what is happening is not the simple act, in its mechanical coldness, of capturing someone else's image: the gesture of appropriation that gives rise, in those who feel targeted by the lens, to a feeling of rejection, not to mention violation. Even when printed up on glossy paper their pictures retain something of a warmth experienced and shared, a trust established, if only for a moment. A natural acceptance of photography, in which those photographed do not feel obliged to adopt a pose.

The photo-reporter David Burnett, who started at *Time* before becoming the co-founder of the Contact Press agency and received the 'Robert Capa' Gold Medal in

1973 jointly with Chas Gerretsen and Raymond Depardon for his reportage from Chile before and after the Pinochet coup, proposes another definition of 'close enough'. We are not here talking about the obsessive quest for the precise moment that will produce 'the weight of words, the shock of photos', to quote the famous advertising slogan for *Paris-Match* (founded in 1949). The key is knowing how to capture what is happening all around, those extra few elements that can make sense of it all. These can be quite minimal and it all depends on the photographer's sensibility. It has nothing to do with a quest for shock images. Only if one succeeds in this does one get to the heart of the event: or as close as possible.

*

It sometimes happens that in Gerda and Capa's work we have two different shots of the same subject taken almost simultaneously. This is the case resulting from their first visit to Barcelona, where there is one 35mm format photograph and one 6 × 6cm, showing a couple sitting side by side in wicker armchairs, he dressed in *mono azul* and militiaman's cap, carelessly holding his rifle, she in a short-sleeved dress, her arm resting against the hand that holds the rifle: they are relaxing and laughing with pleasure at being together in the bright sunlight. If one recalls that at that time Gerda preferred to work with the Rolleiflex and Capa with the Leica one can attribute the 6 × 6cm picture to Gerda and the 35mm to Capa. The positions are almost the same but the framing and light are

different. A demanding judging panel, in one of those amateur competitions where technical perfection is valued above all, would probably single out Gerda's picture, which presents a wider view, with more surrounding space. There is more light and shade, lending greater relief to the figures. One can see the trees in the garden, the man's free hand plays the role of the elementary and obligatory foreground. Capa's picture, more concentrated, lacks relief, the framing is careless, where his working companion's picture betrays careful application. Gerda positioned herself squarely in front of the subject, she focussed on the scene to the point of isolating it at the centre of the composition. Capa, on the other hand took it from a little higher and as a result another seated figure can be detected, cut off, and in the background the feet of a passer-by which should not be there, except to show not only that the photographer couldn't care less about disruptive details of this kind, but that, on the contrary, he welcomes them. So much so that, in the limited available space that remains, one may discover a life that is absent from Gerda's picture, a life evoked by fleeting patches of light, suggestive of the play of sunlight on the ground, something not seen in her picture.

Which of the two photographs is the 'better'? The differences in the handling of the cameras – more immediate and spontaneous with the Leica held directly in front of the eye, slower and more considered with the Rolleiflex at chest height – makes it impossible to draw conclusions about any fundamental difference of approach. It can reasonably be supposed that Gerda – who was still in her

early days – was aiming at greater perfection in the art of making a 'beautiful' photograph and that she was more attached to the conventions that are considered to govern this kind of beauty.* But in both cases this is what counts: the reader must be convinced that these characters, who know perfectly well that they are being photographed, have allowed it to happen in all confidence. Not only do the lenses of the two passers-by who have stopped in front of them not disturb them, the latter are sharing in their joy. A natural complicity, which in the resulting print results in perfect harmony between the various participants; the people in front of the camera, the photographers behind it and the viewer who is himself invited to join in, as if he were catapulted back into the moment when the picture was taken. Confidence is the real issue, the real subject. What is expressed here is confidence in the future, in the first days of the revolution: 'We who laugh are the victors: we are the people of Barcelona and we know ourselves to be invincible.' We move from the familiar to the lyrical without even noticing. And of course, for us who know what followed, there is an added pathos linked to the mass of suffering that is,

*Of course this brilliant analysis falls to the ground if the hypothesis is reversed: if Gerda used the Leica and Capa the Rollei. But why be put off by so little? The analysis can also be reversed. It could equally be argued that the rigour of the framing and the elegance of the composition in the 6 × 6cm picture is due to Capa's experience and that what was described as careless in the 35mm picture is the result of Gerda's inexperience. All of which is to demonstrate that, when it comes to writing critical commentaries on photographs, one can, in fact, say anything at all . . . and still land on one's feet.

as we know, due to overwhelm this present happiness, which neither those photographed nor the photographers yet know to be ephemeral.

*

Here, even if only loosely, even if the word is hackneyed today, we must speak of 'humanism'. Years before the big exhibition 'The Family of Man' (at the Museum of Modern Art in 1955), which would include photographs by Capa, it is already the great human family being photographed in all situations. And most particularly in the worst of all: war. Already the act of faith is being affirmed: 'People are the same everywhere.' Except that this must be added: yes, people are the same everywhere, but everywhere also, and always, they are unique. The faces caught by the lens are far from anonymous (and the proof of this is that since then, people have forever been putting Christian names and surnames to the Spanish militiaman, as they have done to the GI on the beach at Normandy.) Each individual has their own singularity, each *speaks* to the viewer. As do the photographs of destruction, of ruins, of victims, expressions of weariness, of fear, of unfathomable wretchedness. These rebound on the enemy, they identify him, they denounce him, without there being any need – except in rare cases of resigned prisoners – to show his face: evil has no need of a face, it is known to be hideous once and for all. And it, too, is everywhere. But it has, of its own accord, excluded itself from the family of man.

In 1937 Virginia Woolf wrote in a letter to an unnamed male correspondent, an eminent lawyer, on the subject of the 'photographs of dead bodies and ruined houses' received from the Spanish republican government, that 'if they don't make you repudiate war, then you are a monster.' (The letter forms part of her book *Three Guineas*, published in 1938.) For her these images can only pose the essential question: How to prevent war? They have no power to give an answer. And in attempting to find this answer, she begins by spelling out that she is a woman and her correspondent is a man: their points of view are therefore of necessity different, because men make war and women suffer it. This may be why, in certain of Gerda's later photos, as we know them from *Regards*, we find less reserve, less restraint, than in those of Capa: people in pain, dead bodies, images eloquent of the death throes of powerless populations. Is this a question of a female sensibility, inaccessible to men, as Virginia Woolf defines it?

Be that as it may, it all looks as if Gerda herself thought her photos could stop the war. Or at least make an effective contribution to stopping it. And here the distinction laid down by Virginia Woolf does not hold. When she decided to remain in Madrid because the situation was growing more and more serious – literally: *too hard* – was it solely from a desire to take sensational photographs? Or because she saw her camera as a weapon, aimed in unison with the guns of the men? Capa was in Paris, preparing to go to China. He knew his presence would make no difference to the defence of Madrid.

Gerda stayed, as if, however minutely, her pictures could play a part in the outcome of the battle.

We always end up here: can a photograph change the course of events? Or at least exercise an influence on it? At the time, Gerda, Capa and the majority of this new breed of photojournalists, enthusiastic about the wholly new freedom that new techniques brought to their work, were to a greater or lesser extent in thrall to this idea. One can at once see where it might lead: seeking out images and, worse still, events themselves, which are in keeping with the 'approved' tendency. And behold, in the light of this, the question of the authenticity of that picture of the falling militiaman reasserts itself. The examples of faked news pictures, taken for financial gain, which have convinced readers at the time and have later been duly denounced, are legion. One of the prime examples of the genre is that of the Soviet photographer Yevgeny Khaldei, who took world famous photographs of the fall of Berlin: dramatic tableaux orchestrated in every detail after the victory. The soldier brandishing the red flag on top of the Reichstag was especially engaged for the occasion and the flag itself was ordered from a tailor. To round off the job, one of the two watches worn by the man – one on each wrist – was later airbrushed out, so that he should not look like a looter. Moreover Yevgeny Khaldei in fact confided that all he had done was to copy the process used by the Associated Press photographer, Joe Rosenthal for his picture of GI's planting the American flag on Mount Suribachi on Iwo-Jima in February 1945.

Another offhand observation has also been attributed

to Capa: 'No tricks are necessary to take pictures in Spain. You don't need to pose your camera. The pictures are there and you just take them. The truth is the best picture.' This is perhaps a little concise. And one might cite in opposition to it the testimony of John Steinbeck, after their shared visit to the Soviet Union: 'Capa's pictures were made in his brain – the camera only completed them . . . He could show the horror of a whole people in the face of a child. His camera caught and held emotion.' It is true that, though couched in the form of praise, this testimony has something simplistic about it. It throws overboard all those elements of spontaneity, of intuition, of improvisation, of immediate response to the situation and almost physical empathy that can be found in one of Capa's photos. But there remains this suspicion of a premeditation which would take the photographer straight to where he has already firmly decided to go.

When one studies the photos of Spain, bearing in mind those contact sheets: the 6 × 6cm for Gerda and 35mm for Capa, one notes that many of Gerda's pictures seem directed by the wish to exalt certain values. Faith in the victory: a child in Barcelona wearing a militiaman's cap and leaning on his father's shoulder, both of them looking straight ahead, as if they could already see a vision of a radiant future. The dignity of labour: the first harvest on the lands collectivised in 1936. The determination of a whole people: a peasant on his donkey with a raised fist, as if defying the enemy on his land. The heroism of the struggles of the humble. All of these are values that also underlie the imagery of the Soviets and their

vision of the march of history, which will bring forth the 'new man'. More than Capa, Gerda seemed to believe that, by dint of giving people certain images, one will end up making them resemble those images. For the good cause, naturally. That of 'man, that most precious capital', as Stalin put it. Like millions of people at that time, Gerda seems not to have had any inkling of the hideous reverse side to that slogan. Hers was a political humanism in its infancy. Art in its infancy. Let us return to the notion of grace: for what would save Capa, as it would, I hope, have saved Gerda, was that he always retained something of the gaze of a child.

But in the end it must be admitted: the few photographs by Gerda which are available to us now indicate a tendency, more marked in her work, it seems, than in Capa's (though he is not free of it), to conform to the demands of socialist realism. While Joris Ivens succeeded in filming superbly framed scenes that combine beauty with poignancy, Gerda's pictures speak of a reality that is too often willed, to the extent that they are designed to serve, to exalt, the republican cause. George Orwell would later speak of intellectuals building 'emotional superstructures' over non-existent events. 'I saw, in fact, history being written,' he writes, 'not in terms of what happened but of what ought to have happened according to various 'party lines'.'

This feeling about Gerda's work is reinforced – and perhaps distorted – because mostly what remain to us are the pictures kept, displayed and published by 'committed' papers like *Regards* and *Ce Soir*; thus necessarily, those

113

that illustrate the editorial line most closely – a line that had no use for nuances. This is particularly marked on the covers of *Regards* which reach great heights of tendentiousness. Thus the number for March 18 1937, announcing the reportage by 'Capa and Taro' on Málaga, plasters the front page with the image of a woman on horseback, evidently intended to represent the incarnation of Spain – suffering, but resisting and heroic.

*

It is time to make clear that Gerda was not the only female photojournalist to report on the Spanish Civil War. At least one other was active in Barcelona during the first months of 1937. Kati Horna, then aged twenty-five, was Hungarian. She had worked in Berlin with Bertolt Brecht, later in Paris, where she was linked with the surrealists. She had already been taking pictures for the Photo agency during her Parisian exile. Did she ever meet Capa and Gerda there – at the Marché aux Puces, for example, or on café terraces? Commissioned by the Republican government to compile an album of photographs, she basically covered the anarchist militias, the FAI and the CNT. When in Barcelona she published pictures in Spanish periodicals such as *Tierra y Libertad, Mujeres Libres, Tiempos Nuevos* . . . Naturally, these pictures, like Gerda's, have a political message and goal: they show the determination of the fighters, the sufferings of the people, the barbarism of the enemy. But in them can be found something more familiar, more ordinary, closer, in fact, to

a lived reality. Sometimes there is a small scale intimacy. Is this due to the fact she was not aiming to sell them to the big agencies and was even making a gift of them to the Spanish press? I do not know much about Kati Horna's life. For example, I do not know how, though financed by the Republican government, she was in effect able to work exclusively – and it seems freely – with the organisations of the far left, nor how she was able to leave Spain. I know only that, exiled to Mexico, she spent her whole life there, taught photography to several generations and became known there notably for her work for the celebrated review *S.Nob* in which Alvaro Mutis published . . . And also that she preserved 272 photographs and gave them to Spain before her death in 2000: several exhibitions have been organized since then. In the little I have seen of these pictures I have experienced the feeling one gets when friends make the supreme gesture of trust of allowing you leaf through their family albums.

I do not know whether Gerda Taro and Kati Horna had occasion to meet. On the other hand, Gerda certainly knew and spent a good deal of time, along with Capa and other journalists and writers, with a famous photographer of an older generation, Tina Modotti, who was, furthermore, the only woman photographer whom one can really describe, thanks to her total militant commitment, as 'revolutionary'. Her work of the nineteen twenties forms a part of the great history of photography. Her 'woman with a flag' served to illustrate the cause of revolution world wide in the same way that Capa's 'death of a militiaman' served to illustrate the cause of republican Spain.

A committed communist, Tina Modotti worked for Willi Münzenberg, notably in publishing pictures in the *Arbeiter Illustrierte Zeitung*. She proclaimed loudly and clearly that she was putting her skills at the service of the cause she supported. 'Photography is designed to record objective life in all its aspects. If the sensibility and competence of the photographer are combined with a clear idea of the place photography occupies in history, I believe it is worthy to play a role in the social revolution to which we must contribute.'

Did there come a moment when she decided that this role no longer sufficed for her and that she wanted to fight with other weapons than a camera? Or could an order have come from Willi Münzenberg, or indeed from higher up in the hierarchy of the Comintern? The fact is that in Spain she abandoned photography to become a front rank activist in Red Aid. Her biographers mention passionate arguments in which Capa and Gerda tried to persuade her to return to the profession that had made her famous. In vain. Subsequently, having returned to Mexico in secret, she continued her life as a revolutionary activist and died in 1942 in mysterious circumstances, highly suggestive of her having been assassinated.

To bring up the figure of Tina Modotti in connection with Gerda Taro is not merely to indulge in anecdote. And it is not innocent either. It allows us to understand why, whatever Gerda and Capa's humanistic, progressive and committed ideals were, in contrast with those of an activist like Tina Modotti, they always put their art first, never sacrificing it to 'the revolution'. In this sense, even

when they took extreme risks, they were never themselves activists, still less 'revolutionaries': this they always left to their photography and to the active subjects they portrayed.

*

Later on, much later, the political drive underlying photojournalism would evolve and the logic of the market place would take over, following the failure of ideologies. In her essay, 'Regarding the Pain of Others', Susan Sontag has explored the whole process whereby images become banal. Shock effects cancel one another out, the reader's gaze, solicited at every moment, becomes saturated. And if everything cancels itself out, everything is of equal value. Except that if a product is to be imposed on the market it must appear to have more value than the rest. From now on the object is no longer to persuade the reader, whose state has evolved from that of thinking being to that of consumer, of the justice of a cause, to incite readers (in Capa's phrase) to 'hate somebody or love somebody', to 'have a position.' The object is to stay on top in a fiercely competitive race towards the ever more spectacular. The law of the jungle. All methods are justified. What this leads to is the photograph Eddie Adams took in Saigon in 1968: the Chief of the South Vietnamese national police holds his gun to a suspect's head and shoots him down in the street. Death on camera, the execution victim's face in close-up. An execution that would not have been carried out, Susan Sontag tells us, if

journalists had not been available to witness it. It is the logical conclusion: the photojournalist is no longer a witness of the tragedy. Not merely a voyeur. Not merely, even, an accomplice. He is its perpetrator.

We have passed through to the other side of the looking glass. Just as others were ready to die for their country, or for the Party, Gerda Taro, in the last year of her life, was ready to die for photography. And gave proof of it. As Robert Capa did, after her. As did their friend, David 'Chim' Seymour. The list is long. But in Eddie Adams's appalling set piece it is no longer the photographer behind the camera who risks his skin. The one who dies for the sake of a picture is the man murdered in front of the lens. And everything takes place as if the object of this murder were to satisfy the photographer.

One day (on his return from China in 1938) Capa, overcome with weariness, confessed that he felt he had the soul of a vulture. It is not entirely by chance that he died on the first war reporting assignment where he did not have to take sides: the colonial war in Indochina, which he had agreed to cover, he said, as a mercenary. Other photographers have given up news reporting to return to a different mode of contact with reality, faithful, perhaps to the humanism of earlier days: the anxious quest for that brief instant in which an awareness of our surroundings coincides with the click of the camera. Where an encounter occurs, in the 'snapshot', between the long road travelled by the photographer (that being who goes on foot, as Cartier-Bresson puts it) and the image that imposes itself on him, as if chance had suddenly become a

necessity. The constant search for the decisive moment. The journey to the endlessly elusive limits of a sense of rhythm, so that, with luck one may- does one ever know for sure? – transmit to those who view the image thus captured a fresh clarity in their perceptions of the world and of their fellow beings. A desire to share a true image, not one more true than nature but one which, itself, becomes a part of nature and which deepens, enriches and modifies the meaning of nature. Camera eye. Eye ever magical.

In her short life as a photojournalist Gerda Taro had time to put into practice what it was she admired in the novel about John Reed: 'life, liberty, the pursuit of happiness.' Like her model, she hoped that if anybody wanted to know about the war they could learn about it from the pictures she published. Like Reed, the 'Westerner words meant what they said'. She was a woman from the East for whom photos meant what they said.

But in this ambition, which she wanted to share, to be the best photographer in a better world, one can make out the ghost of that angel of history painted by Paul Klee which progresses backwards. A cruel angel which often punishes severely those who follow it. The great family of man that Capa went on wanting to photograph, as they had both done in Spain until Gerda died of it, where is it today? The future, like the horizon, recedes as one advances: that was one of the standing jokes in the days of 'socialism really existing' and it is the lesson history has not ceased to give for half a century. The future, the *Zukunft*, which led Willi Münzenberg to his death, does

not do any favours to those who dare to look history in the face and hope to change its course, like those children who try to look straight into the sun. Yet where would the world be without them?

*

Let us imagine that Gerda Taro survived. Everything is possible, of course, and one can picture her (why not?), pursuing, without Capa, a career marked by her early success, continuing to propagate an increasingly stereotyped image of humanity, always conforming to the canons of a 'better world', denouncing evil in the name of the radiant future, even as she lost her illusions, and, following the example of a Brecht or a Heartfield, returning to East Germany covered in honours, and not just posthumous ones. My personal preference has been to dream of finding her sixty years later, celebrated, with the work of a long life behind her, shaped by the harsh ordeals she would certainly have undergone if she had remained in France, refusing to follow Capa to the United States or Ted Allan to Canada, thrown back into her condition of a stateless wanderer. Only to surface again, forever the will o'the wisp, a camera eye, 'incredibly light', among her fellow beings, to travel the world, to love it and love its images in all their diversity. And, at the end of her life, to be photographing cats. Perhaps because they are reputed to have nine lives. I owed her that, at least.

POSTSCRIPT

It was in 1959 that I first put a name to photos by Capa. I had decided to publish a series of books starting with *La Guerre d'Espagne* by Pietro Nenni. Read today, this book, part history, part memoir, would seem somewhat brief. Not so in 1959. It was, in fact, the first book on the Spanish Civil War to have appeared in France in twenty years. The Second World War had eclipsed that earlier conflict even though the latter had served as a prologue to it. Perhaps this profound forgetfulness was mingled with an element of bad conscience, a feeling of guilt, even. The policy of non-intervention, the refusal to assist the Republic, resignation vis à vis Hitler's and Mussolini's support for the fascist rebellion. There was also France's criminal attitude in the face of the distress of the exiles, their internment in camps, at Argelès, Gurs, Le Vernet and others . . . so many memories it was better not to revive. So the crucial role of veterans from Spain in the French

resistance was passed over in silence. Nobody knew or wanted to know that the leading tank in the Leclerc Division which drove into Paris to liberate it had a crew of Spanish republicans . . .

For the publicity for that book I wanted to have some photographs from the period. My friend Jean-Philippe Bernigaud obtained from the Magnum agency some photographs which were, I learned, by Robert Capa. Magnum generously allowed him to make enlargements from them, which looked all the more striking in bookshop windows because they were almost life size. Capa's photographs played a big part in the success of the book, without which our publishing programme would not have continued. Thus my early days as a publisher remain intimately linked in my memory with the image, among others, of the militiamen of the Union of Proletarian Brothers setting off for the front. Later on, again thanks to Magnum, another of Capa's pictures, a woman gazing at the sky during the siege of Madrid, appeared in the edition I published of the *Romancero de la Resistance Espagnole* ('the Romance of the Spanish Resistance'.)

Many years later, round about 1990, my friend the photographer Anaïk Frantz gave me a copy of *Robert Capa* by Richard Whelan. Beyond my liking for the man and my admiration for his work, reading it, along with other books, enabled me to question myself further about what this mysterious activity of photography, half art, half craft, represented to me and about the photographers themselves, often disconcerting individuals.

It was in Richard Whelan's book that I first came

across Gerda Taro. I was all the more struck because I had just published a novel, *Le Figuier* ('The Fig Tree'), in which one of the characters was a refugee from the Spanish Civil War and another was a young woman photographer. By dint of regarding her profession as a battle and her camera as a weapon, the latter ended up no longer content to be a mere witness and decided to 'cross over to the other side of the lens'; to fight alongside those whom, up to that moment, she had only been photographing. This led to her death. I was thus seeking to raise the question of the value and the limits of bearing witness, seen as a battle for the truth. And of the traps that lie in wait: the temptation to abandon the position of the witness – whether one who writes or one who takes photographs – when the questioning about its ambiguity becomes too insistent, when unease and dissatisfaction in the face of the goal striven for succeed in winning the day. I often discussed these things with Anaïk Frantz, when we were travelling through the poor outer suburbs together, to compile the album of her photographs *Les Passagers du Roissy-Express* and when she published *Paris bout du monde*, her 'family album', in which, on every page, she can not only name every woman and every man she met but tell their life stories. The same with Klavdij Sluban, when we travelled together through the countries of the Balkans to compile *Balkans-Transit* and on other journeys too, in the course of which I always saw him searching for the right distance, to ensure that a work of photography – but not only that – makes sense.

Taking as my starting point the affinity between the

fictitious character in my book, Mary Kendale, and the real character of Gerda Taro, I ended up writing a short story, 'Gerda', which is included in my book *La Vol de la mésange* ('The flight of the titmouse'), a book in which I attempted to let this question of witness run through it like a thread, highlighting the role it plays between efficacy and vanity, sincerity and alibi. To bring Gerda Taro to life all I had available was the sparse information gathered from various books, studies and articles about Capa and what emerged was still much too hazy a figure: hardly more than a shadow.

For a long time, however, it was the character of Capa that continued to fascinate me. Perhaps because he had contrived to exercise his freedom as a man in extreme situations and had found a way of enabling this sense of freedom to pass into his photography – restricting art form though it is. As I contemplated his work many doubts and many questions disappeared.

In 2004 Editions Desmarets in Strasbourg asked me to write some thirty pages on an individual of my choice for a collection of short books called *'Les Insoumis'* ('The Rebels'). I suggested Robert Capa to them. At that moment the big exhibition, *Capa connu et inconnu* ('Capa Known and Unknown') at the Bibliothèque Nationale of France was announced. This gave rise to so many exhaustive studies that, amid this great chorus, I no longer had a clear idea of what would be the point of such a text – at least at that time. At all events, a certain delay seemed necessary. On the other hand, I continued to be attracted as well and – insofar as so little was known

about her – intrigued by Gerda Taro. All the more because, in writing my short story, something had happened to me which occurs sometimes when one becomes attached to a character to whom one seeks to give – or restore – a little life through the medium of words. By dint of my evoking her, Gerda's shade had finally begun to take on shape and colour, to appear fleetingly in the course of a waking dream, reminiscent of Wilhelm Jensen's romance, *Gradiva*, made famous by Freud: a little more than a phantom, a little less than a living person. All that it needed, in fact, for me to be able to fall in love with her in the brief moments when I glimpsed her – as the hero of Jensen's novel had glimpsed Gradiva in the ruins of Pompeii.

I therefore decided to put my text about Capa on hold and go more deeply into the character of Gerda Taro meanwhile. I had a meeting with Bernard Lebrun, star reporter on the television channel France 2, whom I had wanted to question about Capa and who talked to me passionately and at length about Gerda, and this was certainly highly relevant. I knew he was working on a film about her. I hoped it would see the light of day before my text appeared. I am still hoping that it has only been postponed. He it was who referred me to Irme Schaber's book, *Gerta Taro, Fotoreporterin im Spanischen Burgerkrieg: Eine Biographie* ('Gerta Taro, photojournalist in the Spanish Civil War: a biography'), which he regretted not being able to get published in France, a lack since repaired.

Reading this book in its German edition clearly

enabled me to fill in gaps, to correct errors, to give substance to the little I already thought I knew of Gerda Taro. To sharpen the picture I had of her, to really let her emerge from her sad, shadowy state. And as I extended my research into the climate of the period, the involvement of artists in the Spanish Civil War, their conception of their role and, more specifically, into their conception of the profession of photojournalist and how this evolved, I went far beyond those three dozen pages originally envisaged and arrived at the present text.

This book is thus greatly indebted to Irme Schaber's biography, especially for the first part, Gerda's youth and friendships in Germany and her early years in Paris. In that biography readers will find a detailed study of Gerda's life, which locates her within the period, and of the political and intellectual circles to which she belonged. And, thanks to the extent of the illustrations, they will be able to form a general idea of her work as a photographer.

I had already completed my own text when I learned that a major exhibition of rediscovered photographs was in preparation in New York. Thus, after almost sixty years of being forgotten, the memory of Gerda Taro is about to be revived in the full light of day.

Her disappearance, the fading of her work from the collective memory can be attributed to a variety of causes. I have already referred to the way the recollection of the Spanish Civil War itself had been banished from people's memories just after the Second World War: figures such as Gerda were the sad victims of this and no

one can be blamed. Certainly not Capa, whose first concern, on the contrary, was to perpetuate her memory by dedicating *Death in the Making* to her in 1939 and by including in it, mingled together, photos taken by both of them. It was, indeed, the only act of love that could still have had any meaning. The fact that he did not then immediately separate out his own pictures from Gerda's, all of them being preserved together and no doubt in great confusion, due to yet another exile – from France to the United States – indicates nothing more than carelessness. One should not forget the climate and anxieties of the period. Capa was lucky to escape the internment that struck anti-Nazi émigrés in France. But much of his archive material, left in Paris, was hidden, dispersed, or seized by the police. It is only recently that some of his notebooks have been recovered, though even now without it being possible to establish the route by which they have come to us . . .

To this it should be added that the Pohorylle family, exiled to Yugoslavia, perished, murdered in the course of the Nazi extermination of the Jews of Europe. It therefore seems as if there was nobody after the war who could present themselves as the rightful owner of Gerda Taro's estate and concern themselves over the fate of what remained of her photographic work. The fact that, in these circumstances, photographs by her, included in the Capa collection, should have been listed at the Magnum Agency or elsewhere as 'Photo Capa', is alas, comprehensible. Especially after 1954, the year in which Capa stepped on a landmine in Indochina. What matters today

is that her pictures survived, that they have come into our hands and can at last be credited to the photographer who truly took them. And who has the privilege of remaining, in all our eyes, as young as the day of her death.

November 2005

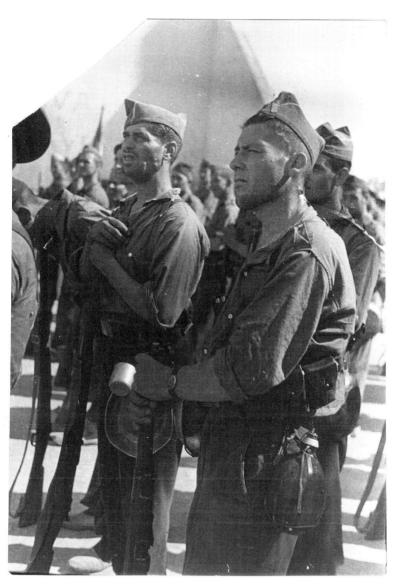

15. Brunete, July 1937.
Photo: Gerda Taro.

Select Bibliography

(Where English language editions of works consulted by the author in translation are available the details of these are listed below.)

Capa connu et inconnu, L. Beaumont-Maillet (Director), Bibliothèque nationale de France, 2004.

Robert Capa, *Death in the Making, Photographs of Robert Capa and Gerda Taro*, New York, 1938

Robert Capa, *Juste un peu flou*, Robert Delpire, 2001.

Robert Capa (introduction by Jean Lacouture), Thames and Hudson, 1989.

Régis Debray, *L'oeil naïf*, Seuil, 1994.

Raymond Depardon, *Images politiques*, La Fabrique, 2004.

John Dos Passos, *Nineteen nineteen* in *U.S.A*, Penguin Modern Classics, 1976.

The Family of Man, Museum of Modern Art, New York, 1955.

Margaret Hooks, *Tina Modotti*, Phaidon, 2002.

Magali Jauffret, 'Le photojournalisme dans le sang', *L'Humanité*, October 12th 2004.

Alex Kershaw, *Blood and Champagne: The life and times of Robert Capa*, Macmillan, 2002.

Stephen Koch, *Double Lives*, HarperCollins, 1996.

Arthur Koestler, *Spanish Testament*, Victor Gollancz, 1937

—— *Scum of the Earth*, Eland, 1991

—— *Arrow in the Blue*, Hutchinson, 1983

—— *The Invisible Writing*, Vintage, 2005

—— *Stranger on the Square*, Abacus, 1985

Mijail (Mikhaïl) Kolstov, *Diario de la Guerra de España*, Ruedo Ibérico, 1963.

Tina Modotti, Maria Caronia, Vittorio Vidali, *Tina Modotti, photographe et révolutionnaire*, Éditions Des femmes, 1982.

Carole Naggar, *Dictionnaire des photographes*, Seuil, 1982.

George Orwell, *Inside the whale, and other essays*, Penguin, 1975.

Gustav Regler, *Le Glaive et le Fourreau*, Actes Sud, 1999.

Denis Roche, *Le Boîtier de la mélancolie*, Hazan, 1999.

Irme Schaber, *Gerda Taro, Fotoreporterin im spanischen Bürgerkrieg. Eine Biographie.* Jonas Verlag, 1994.

—— *Gerda Taro: une photographe révolutionnaire dans le guerre d'Espagne*, Anatolia/Le Rocher, 2006.

Susan Sontag, *Regarding the pain of others*, Hamish Hamilton, 2003.

John Steinbeck, *Un artiste engagé*, translated into French by C.Rucklin, Gallimard, 2003.

—— *A Russian Journal*, with photographs by Robert Capa, Penguin, 1999.

Richard Whelan, *Robert Capa: a biography*, University of Nebraska Press, 1994.

Websites

The photos of Kati Horna can be found at

www.barranque.com/guerracivil/horna.htm

Ted Allan, *The Pen as Sword*, www.normanallan.com

Photographic Credits

Photos Fred Stein © FredStein.com: 2, 4

Photos Gerda Taro © International Center of Photography: 1,3, 6, 10, 11, 12, 13, 14, 15

Photos Robert Capa © Cornell Capa: 5, 7, 8, 9

The author would like to thank the late Richard Whelan, Magnum Photos, the late Cornell Capa and the International Center of Photography of New York for their permission to publish the photos that illustrate this book.

Translator's Note

I am indebted to a number of people, in particular the author himself, for advice, assistance and encouragement in the preparation of this translation. To all of them my thanks are due, notably to Tom Bradley, Barry Cole, June Elks, Andrew Lawson. Pierre Sciama, Simon Strachan and Susan Strachan.

<div align="right">G.S. April 2008</div>

Also available from Souvenir Press

PABLO NERUDA

"The greatest poet of the twentieth century – in any language."
Gabriel Garcia Marquez

RESIDENCE ON EARTH
Translated by Donald D. Walsh
9780285636873 £14.99

Residence on Earth was Neruda's first great work and the expression of his mature voice, political, engaged and committed where Neruda speaks not only for the victims of repression such as his friend and fellow poet, Frederico Garcia Lorca, but for entire continents, as well as being the great poet of the Spanish Civil War.

"Pablo Neruda was easily the most prolific and popular of all twentieth-century poets... At his best, he is among the small group of last century's great poets."
Mark Strand

In *Residence on Earth* he became "the people's poet" addressing the reader with poems that are realistic and refer to the ordinary, exalting the basic things of existence while speaking for a politically committed vision of a reformed world.

MEMOIRS
Translated by Hardie St Martin
9780285648111 £12.99

"Real evocation of the landscapes that were so important to him... In their energy, scope, and exceptional vividness, they alone would justify Neruda's exalted position in modern literature."
'The Independent'

Pablo Neruda's life was an integral part of the history of the twentieth century. *Memoirs* opens with a lyrical evocation of his childhood in Chile, in what was still a frontier wilderness. Following a bohemian youth in Santiago and a career as Chilean consul in Burma and Ceylon, and the agony of his life during the Spanish Civil War. Returning to Chile he became a Senator before being forced to escape on horseback over the Andes, into exile in 1949. He was awarded the Nobel Prize for Literature in 1971 and died in 1973, days after finishing these memoirs.

Written in Neruda's vivid and unmistakable style *Memoirs* depicts an extraordinary literary and political world peopled with the artists, poets and leaders who were his friends: Lorca and Eluard, Picasso and Rivera, Ghandhi, Mao Tse-Tung, Salvador Allende and Che Guevara.

PABLO NERUDA

ISLA NEGRA
Translated by Alastair Reid
9780285649132 £14.99

"Pablo Neruda moves fast, and Reid follows alertly, ingeniously;
his translations in this book are superb."
Robert Bly, 'New York Times'

In *Isla Negra* Pablo Neruda set out to explore his landscape, his roots and experience in an attempt to gather into unity the various "lives" he had left behind in the huge span of his writing career. From the more than a hundred poems he created a poetic autobiography centred round his home of Isla Negra.

The poems move from childhood impressions and awakenings through his early loves, travels and the dawning of his political awareness to self-scrutiny and self-definition. Among their variety Neruda embraces the apparent contradictions of his life. Through-out the poems present and past interact, and this collection becomes the most revealing of Neruda's long career. The poems of *Isla Negra* display the astonishing abundance of the human imagination when mingled with memory.

FULLY EMPOWERED
Translated by Alastair Reid
9780285637252 £9.99

"A passion to connect poetry to everything… and it has a lot to do with
the fact that his poetry is so enduringly popular."
Matthew Sweeney, 'Poetry London'

Fully Empowered was one of Neruda's favourites among his own works, and he specifically asked his finest translator, Alastair Reid, to translate it into English.

The thirty-six poems vary from short, intense lyrics, characteristic Neruda odes, whimsical addresses to friends, and his magnificent mediations on the role of the poet. Within *Fully Empowered* are many poems among the greatest of Neruda's work, including 'The People', his most celebrated later poem.

Anyone familiar with Neruda's work is aware that there are many Nerudas, many distinct poetic styles, and *Fully Empowered* demonstrates the dazzling diversity, in style and theme, of the most inexhaustible poet of the twentieth century.